Greetings from
EARTH

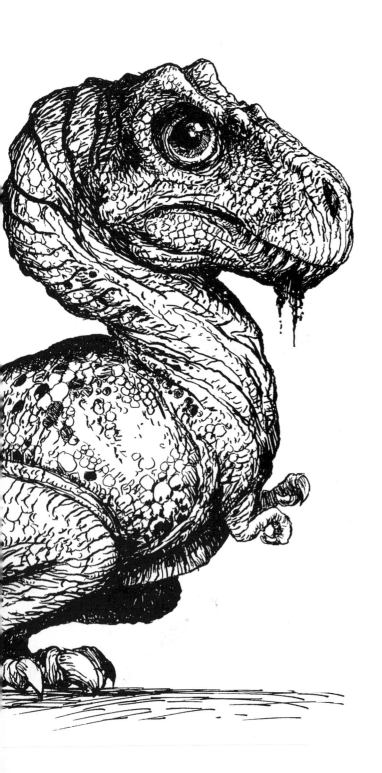

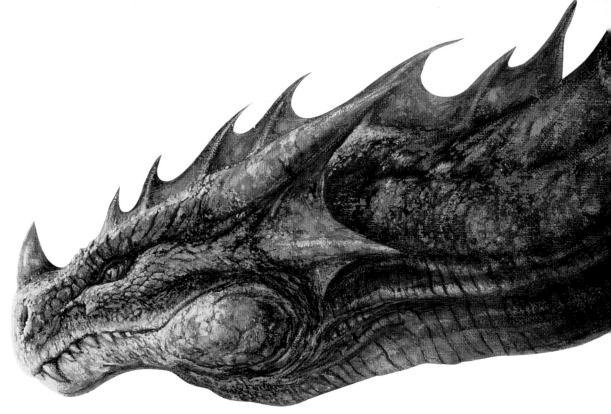

Greetings from
EARTH

The Art of
BOB EGGLETON

First published in Great Britain in 2000
by Paper Tiger
An imprint of Collins & Brown
London House, Great Eastern Wharf
Parkgate Road, London SW11 4NQ
www.papertiger.co.uk

Distributed in the United States and Canada
by Sterling Publishing Co,
387 Park Avenue South, New York,
NY 10016, USA

9 8 7 6 5 4 3 2 1

British Library Cataloguing-in-Publication Data:
A catalogue record for this book is
available from the British Library.

ISBN 1 85585 662 X

Commissioning editor: Paul Barnett
Designer: Paul Wood

Reproduction by Global Colour, Malaysia
Printed and bound in Singapore

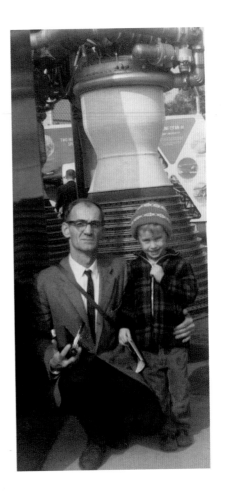

DEDICATED TO
E. RICHARD EGGLETON
(1922-1998)

"To Dad,
Greetings from Earth,
wherever you are..."

Contents

Introduction

Just as we were compiling this book, Bob Eggleton was awarded, for the fifth time in not many more years, the coveted Hugo for Best Professional Artist by the World Science Fiction Convention, being held at the time (1999) in Australia. That year he also received the Chesley Award for Artistic Achievement from the Association of Science Fiction and Fantasy Artists at the North American SF Convention. Along with many other prizes, this probably makes him one of the most popular fantasy artists at work on the planet today, but he has yet to show any signs of complacency, either in slowing down or resting on his laurels. If anything, he seems more restless than ever to exercise his busy imagination in new fields.

As you can see from the paintings we have collected here, Bob's work spans a wide range from straight scientific illustration to the most whimsical fantasy, all tackled with equal enthusiasm and flair. He skips from one genre to another with barely a pause for breath. An ideal month is when he gets to do an sf piece, a fantasy piece, a horror piece and a classic sf story illustration; plus having time to do a painting just for himself. This pace explains how he has been able to fill this book with mostly new pictures done in the five years since his last anthology, *Alien Horizons*. Bob Eggleton is a fierce and constant worker. Even when flying anywhere he tends to pass the time by churning out sketches and picture ideas instead of just watching the in-flight movie.

He has also done much else that for one reason or another we have not been able to show. Besides *The Book of Sea Monsters* that we wrote and illustrated in 1997, many will be familiar with Bob's cult Godzilla pictures for the Random House digest novels aimed at young adults. Still younger readers may have picked up his Star Wars storybook called *Watch Out, Jar Jar!* (published to coincide with the release of *Star Wars: The Phantom Menace* movie) and there have been many other projects besides.

One idea we had for this book was to frame it as a letter to some distant alien civilization. In the event this seemed needlessly complicated, but a ghost of the concept helped to shape this book. If NASA were to ask Bob to put together a personal time capsule to be shot into deep space, this would be it. On the one hand, his aim would be to show aliens something of ourselves and life on Earth. On the other he would like to show how we imagine them to be, though not completely seriously of course.

Since *Alien Horizons* Bob's perspective has noticeably shifted. He has become more grounded, hence the title "Greetings From Earth". It also shows in the selection of straight landscapes that we have included, which may come as a surprise to many of his fans. It is an area he hopes to expand in future.

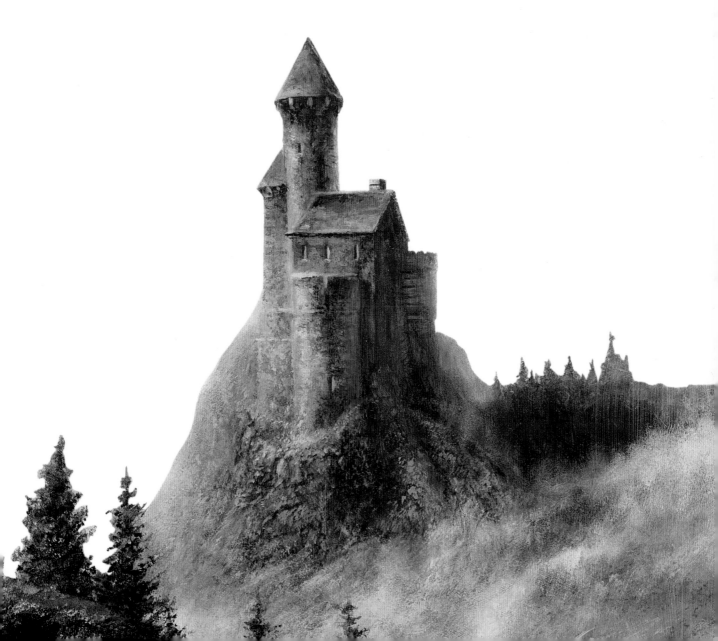

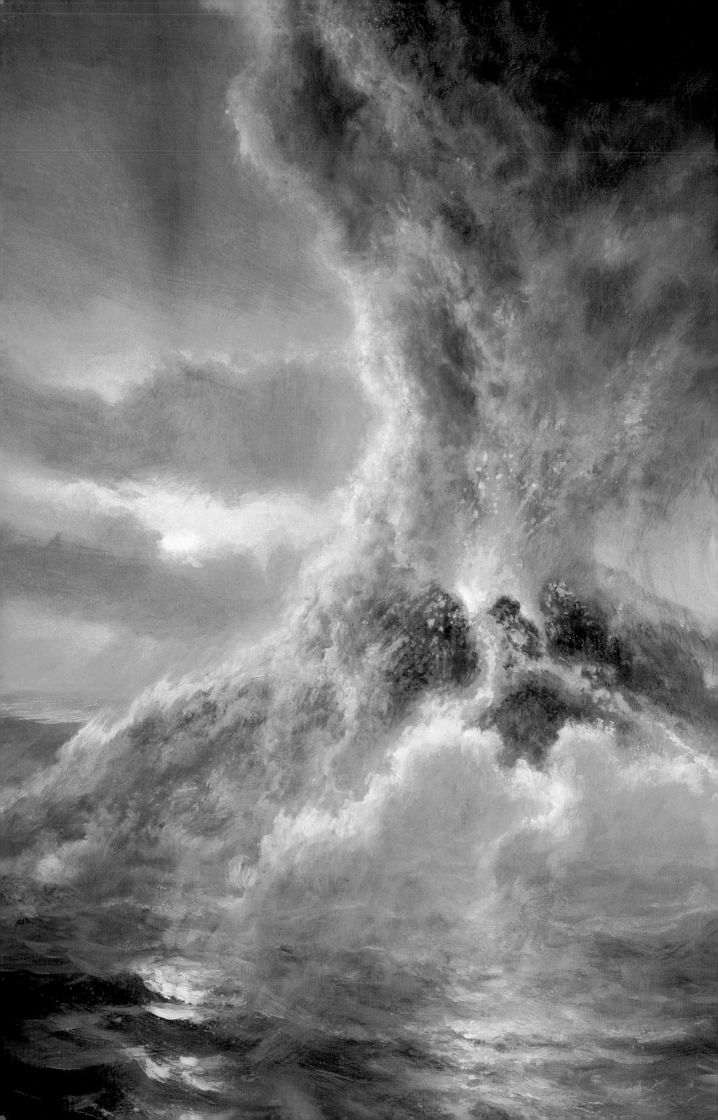

Primaeval Forces

*B*ob Eggleton's paintings cover a range of subjects that to many people seem incompatible. They go from "straight" dinosaur portraits, landscapes and astronomically plausible pictures of deep space to the most whimsical realms of fantasy. But to him there is no conflict. His imagination crashes through the boundaries almost without noticing and the different genres lend strength to each other. Straight dinosaurs give credibility to Bob's dragons and aliens. Fantasy feeds back subliminally into the "straight" pieces to give them an energy often lacking in specialist illustrations. We have all seen paintings of dinosaurs looking like plastic toys fresh from the box. Bob's are more likely to drool and bleed and suffer from skin complaints.

Bob has loved dinosaurs since his father first opened his eyes to them at the 1964 World Fair, where there were some life-size, animated sculptures that he sat upon and was immediately fascinated by. His father also built dinosaur sculptures from old tyres and other scrap in the backyard. This inspired Bob's life-long love of Godzilla, so the ideas of real dinosaurs and fabulous monsters were linked in his imagination from an early age.

Land is Born, 1998
60 x 60 cm (24 x 24 in)
Oils on hardboard
Private work
After visiting Hawaii, the idea of volcanoes simply erupting out of the ocean seemed a great subject for a painting. Even as I worked on it, a volcano burst forth off the western coast of Australia to eventually form a new island. To watch the effect of molten magma as it makes contact with the ocean is truly amazing. More land is created, inch by inch, as the sea relentlessly drenches the tortured rock with its soothing relief. The Hawaiian Islands were formed this way, and it's a process that took tens of thousands of years.

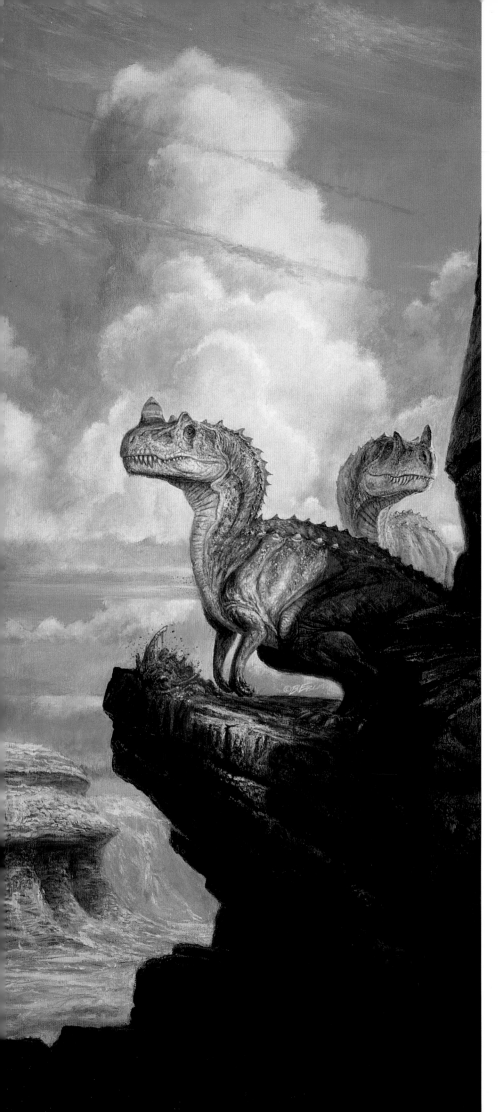

So far Bob has not had much chance to paint dinosaurs professionally, though possibilities are opening up. With books and magazines he finds that palaeontologists tend to have their own favourite artists in mind when writing, and there are plenty around who have been at it for years. So it is a bit of a closed field, but Eggleton is not bitter and admires many of the artists at work in it.

Chief of these artists are the two acknowledged masters of dinosaur painting in the twentieth century, Charles R. Knight and Zdenek Burian. These two, says Bob, stand "horns and teeth above all the rest". Burian's name may be almost unknown to those outside his field, but most of us are likely to know his work if we have ever shown the faintest passing interest in dinosaurs, because his pictures have been reproduced anonymously in countless textbooks.

Ceratosaurs, 1999
90 x 46 cm (36 x 18 in)
Acrylics on canvas
Private work
Another self-commissioned piece undertaken solely because I love dinosaurs. These are two Carnosaurs who have taken their lunch to high ground to tuck into it at leisure. Blood is smeared over the snout of the animal most visible to us because carnivores are generally not endowed with table manners. The rather obvious horns on their snouts may look as if they are for fighting, but the chances are that they were more important for sexual attraction, much as certain modern birds have colourful feathers.

Charles Knight was active from the 1890s to 1940s. He revolutionized the art of painting dinosaurs, bringing them to life in a way that had not seemed possible before. Burian came a little later, born in 1905 in Moravia, Czechoslovakia, where he lived all his life. Besides coming to rival Knight as a dinosaur painter through collaborations with the famous palaeontologist Josef Augusta, Burian covered a wide range of other illustration. Adventure stories included Robinson Crusoe by Daniel Defoe and some classics by Robert Louis Stevenson. He also illustrated Westerns, and even Fantasy novels in the form of the Tarzan adventures by Edgar Rice Burroughs. In all, Burian is said to have illustrated over 500 books before his death in 1981, with an output of some 15,000 paintings, a total even Bob might balk at.

Styracosaurus, 1999

76 x 38 cm (30 x 15 in)

Acrylics on canvas

Private work

This is a pretty on-the-mark recreation of a prehistoric Ceratopsian dinosaur, actually my favourite of many, the Styracosaurus. I wanted the feel of a dank, moist, humid and very ancient forest. The diagonal shafts of light criss-crossing the tree in the other direction create a sense of unease. And with many predatory carnivores wandering about, there indeed would be a sense of unease! Many people are surprised this is painted with acrylics as opposed to oils because of the depth. I use acrylics in a very fast and thinned method, glazing and glazing until the piece basically says: "I'm finished".

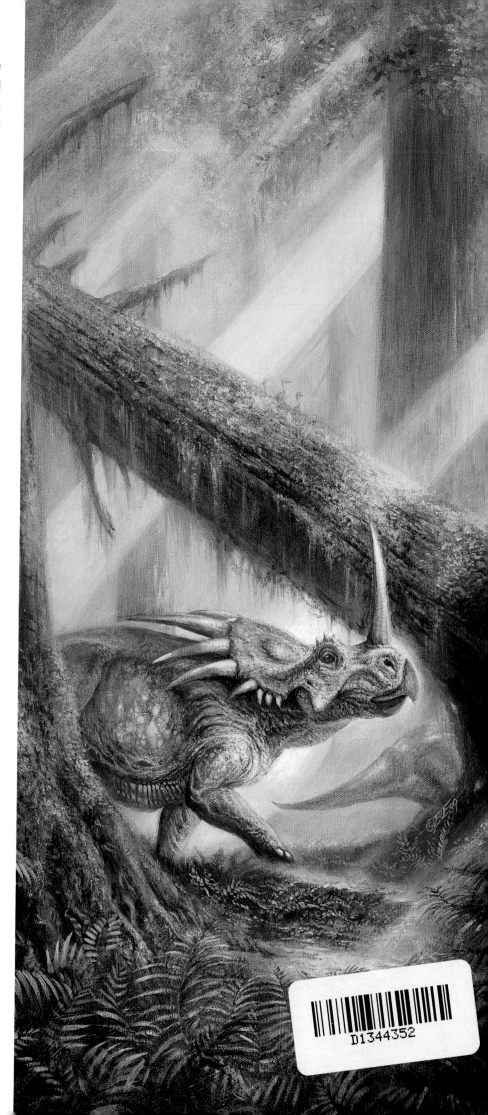

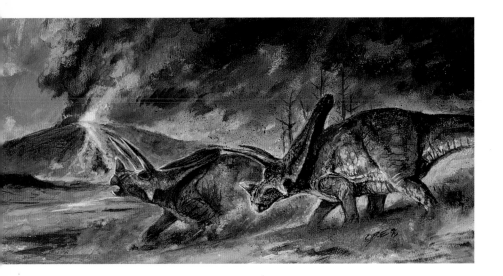

Torosaurs (sketch), 1997

15 x 33 cm (6 x 13 in)
Acrylics on paper
Private work

This was a sketch that came together
because I saw something I wished to
paint in my head, and had little time
due to the fact I had paying
commissions on the front burner. So I
took about an hour to work this out as
a colour sketch. A collector of dinosaur
art liked it so much just as it was that
he bought the original. These
Ceratopsians look much like the
familiar Triceratops, but are smaller
and a different subspecies. The idea
was to convey that two of these herd
beasts have been cut off by the molten
magma tossed up from the volcano.
One day I intend to do a much, much
larger painting from this sketch.

Tyrant, 1997 *(right)*

33 x 33 cm (13 x 13 in)
Acrylics on canvas
Illustration from *The Book of Sea
Monsters*, Paper Tiger

I thought this picture might be worth
another look. I wanted a very dank,
musty feel to this piece. Many dinosaur
artists tend to show their animals much
too "clean" for my taste. I wanted this
T-Rex to look like he was really a serious
animal. He's got a lot of saliva (an idea
I got from Komodo Dragons) and flies
are buzzing about his bloodstained
jaws. The shafts of light through the
trees were something I had wanted to
experiment with for a while. They are
done very simply: I apply a layer of
greenish/yellow paint and use rubbing
alcohol to strip away areas back to the
white canvas.

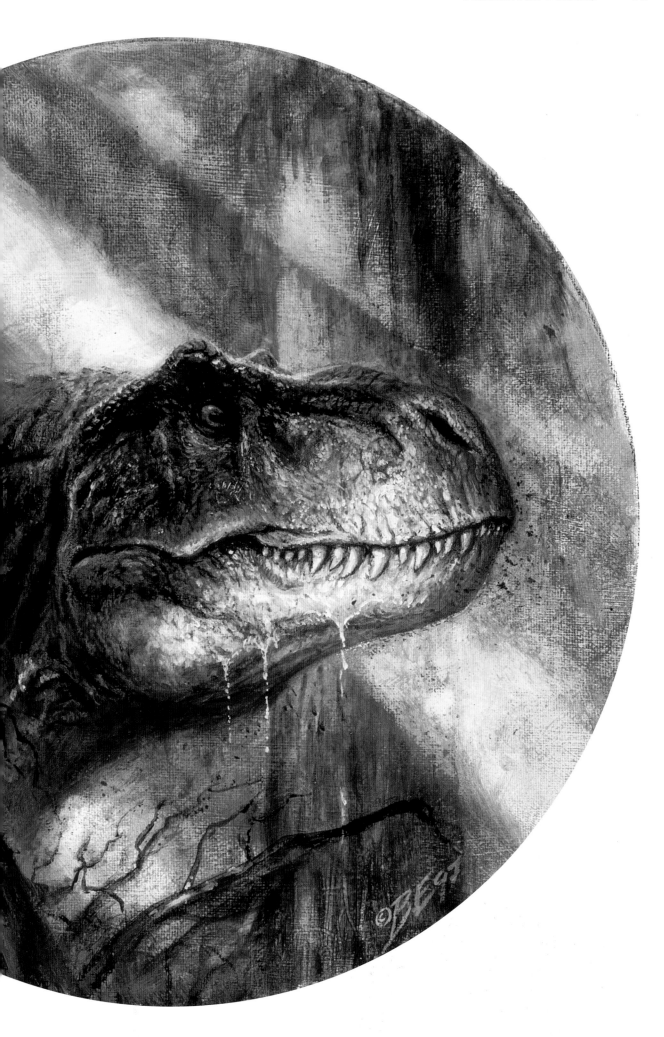

The Dragons of Spring Place, 1998

46 x 60 cm (18 x 24 in)

Acrylics on canvas

Cover for a collection of short stories by Robert Reed, Golden Gryphon Press, 1999

In this particular tale, an island stands as testament to man's undisposable pollution: nuclear waste. The island is a mass of pinkish glass, with vegetation covering much of it. It is also "protected" by gigantic Komodo Dragons. I particularly enjoyed the texture that I was able to create all over the bodies of these creatures, who have grown to Godzilla-like proportions, all done with a painstaking "dry-brush" effect that takes patience to get right. I was able also to put the canvas texture itself to good use. I actually got to see a Komodo Dragon up close and personal in Australia. He was in the Taronga Park Zoo near Sydney in a concrete compound. Fortunately, he was happy to sit quite still – all 10 feet of him – while I sketched and photographed him as he was sunning himself and "smelling" the air with his long tongue. It was nice then to get this assignment and put the reference to such good use!

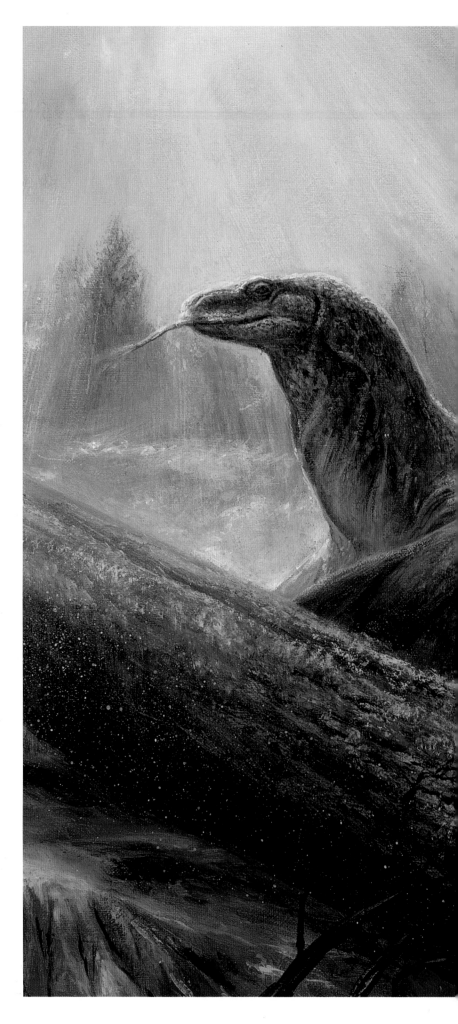

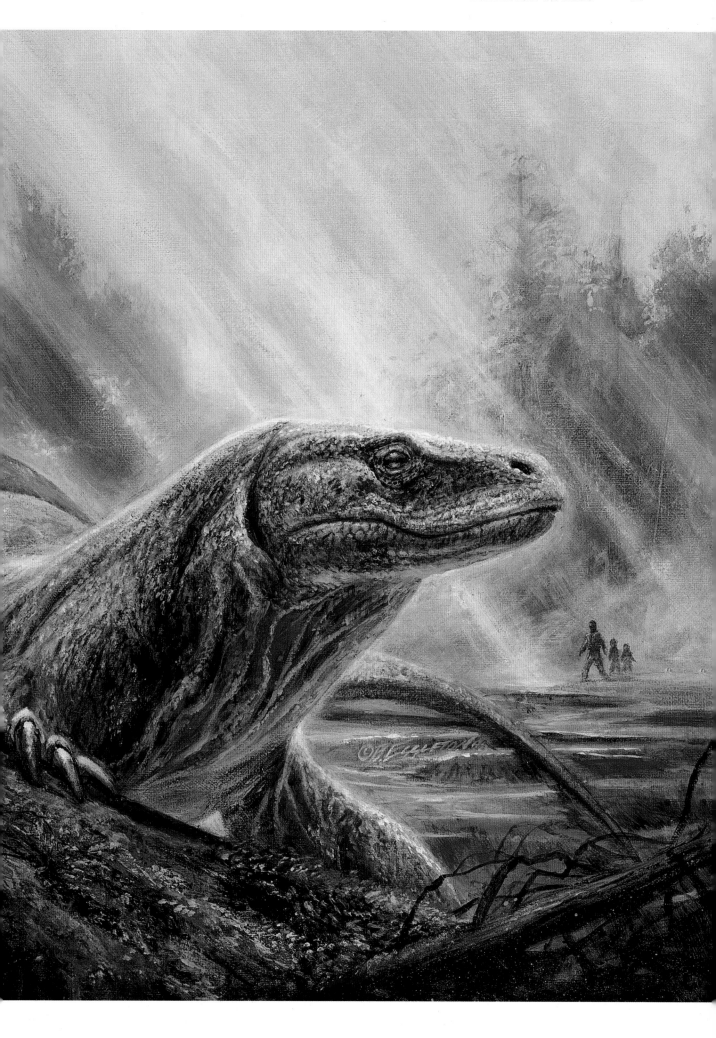

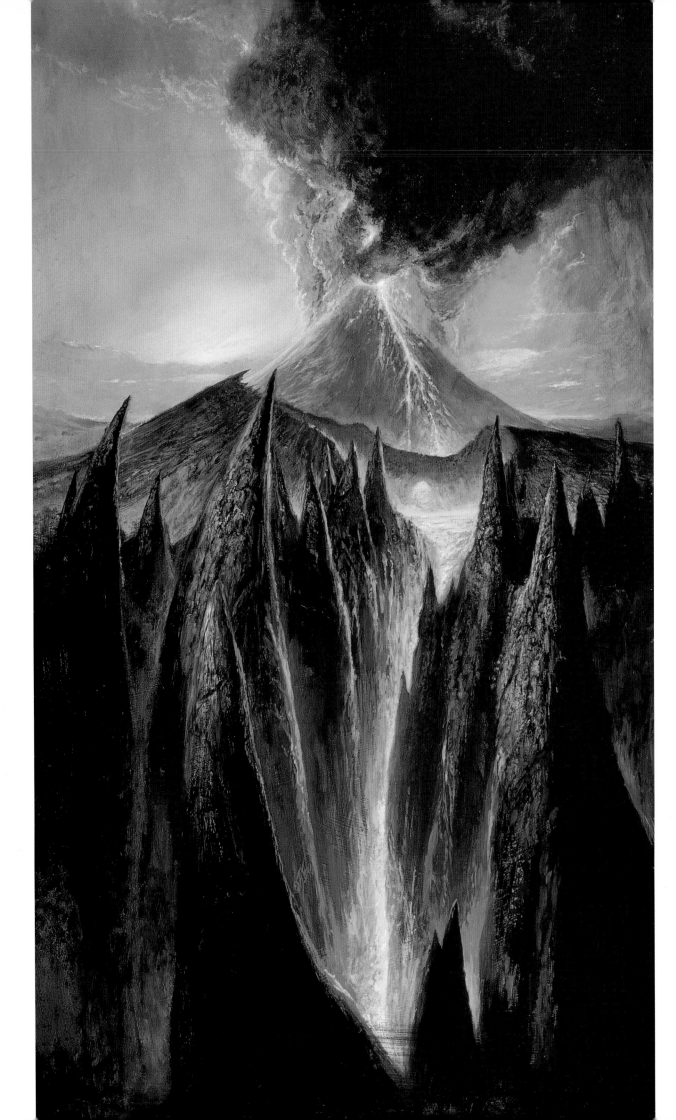

The Pit Dragon, 1998 *(left)*
50 x 40 cm (20 x 16 in)
Acrylics on canvas
Cover for *The Pit Dragon*, an anthology of novels by Jane Yolen, Doubleday Book Club
This dragon is actually a dinosaur-like creature that exists on a prison planet for humans. The picture is rather oddly proportioned because it was intended as a poster as well as a book jacket.

Rage and Despair, 1998
(facing page)
90 x 50 cm (36 x 20 in)
Acrylics on hardboard
Private work
1998 was a year that in many ways I was glad to see behind me as it contained a lot of stress and bureaucratic entanglements. This painting, which was nominated for a Chesley Award for Best Unpublished Colour Work, summed up exactly how I felt, the volcano representing my head and the lava "Pit of Hell" representing my stomach. It's easy to project your feelings onto a painting like this, which flowed very smoothly from start to finish.

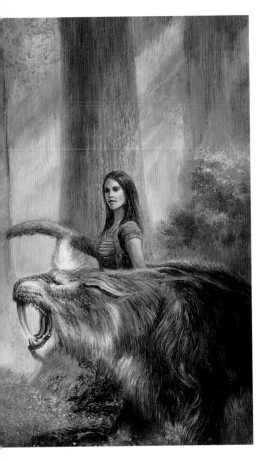

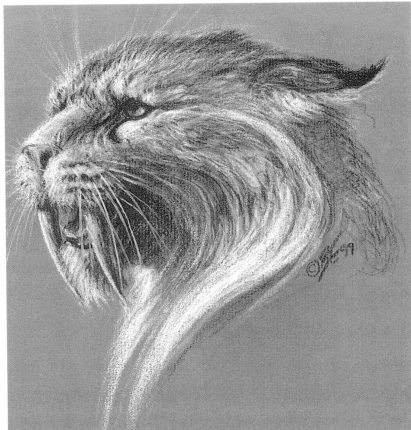

Telzey (study), 1999
40 x 28 cm (16 x 11 in)
Acrylics on canvas
Cover concept, Baen Books
This was a study I did for the classic sf
novel by James Schmitz featuring
Telzey of Amberdom. I enjoyed it, but
the publishers eventually went for a
different design.

Sabre-toothed Cat, 1999
36 x 43 cm (14 x 17 in)
Charcoal and chalk on paper
Study for a larger work
This piece proved quite popular at an
art display, despite the fact it is rather
straightforward and done in black and
white. Like pencil, I find charcoal and
chalk to be inviting media.

Cindy's World, 1999 *(facing page)*
92 x 46 cm (37 x 18 in)
Acrylics and oils on canvas
Private commission
Cindy is the name of the lady who
posed for this painting, which was
commissioned by her husband. The
couple are fantasy art fans and patrons
who have commissioned paintings from
many other fantasy artists, including
Boris Vallejo and Julie Bell. The
instructions were simple: choose any
poses or photos and make a fantastical
painting with them. I put Cindy in an
Edgar Rice Burroughs-type situation
because it is a kind of painting I had
always wanted to do. In the end, it
was hard to part with the piece as I
considered it one of my best recent
works as it had little or no art direction,
which is something most artists wish
for. The flying reptile's colourful skin
was a truly joyful bit of painting. But, a
commission being a commission, the
painting went to its owners, who were
also delighted with it.

Stylistically, Bob is drawn to painters with a loose style of brushwork, many of them
landscape painters. Turner is his all-time favourite, followed closely by Constable.
Ivan Aviazovsky is another, a Russian seascape painter whose works are only just
becoming familiar in the West. Also Thomas Cole, Winslow Homer, Rockwell Kent
and most of the Hudson River Painters.

Among living artists, one of the greatest influences is British artist Peter Ellenshaw,
who painted the mattes for many Disney films including *Mary Poppins, 20,000
Leagues Under the Sea* and *The Black Hole*. Mary Poppins was the first movie Bob
ever saw and he has been completely enchanted by it ever since. Ellenshaw retired
to paint landscapes and is still hard at work in his 80s. He inspires Bob not only as
an artist, but also as a person. He is very down to earth about his success and still
seems to be trying to paint a better picture each time he gets down to it.

Among figurative painters Bob's favourites are Francisco Goya, Eugene Delacroix,
Gustave Moreau and most of those loosely known as Romantics.

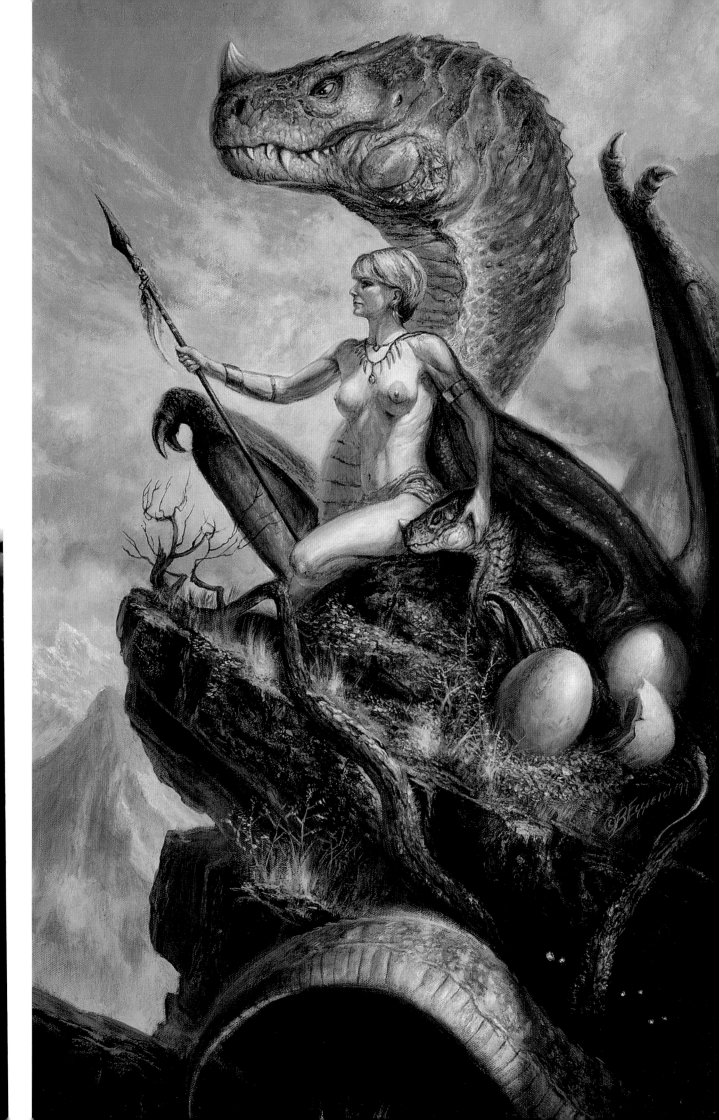

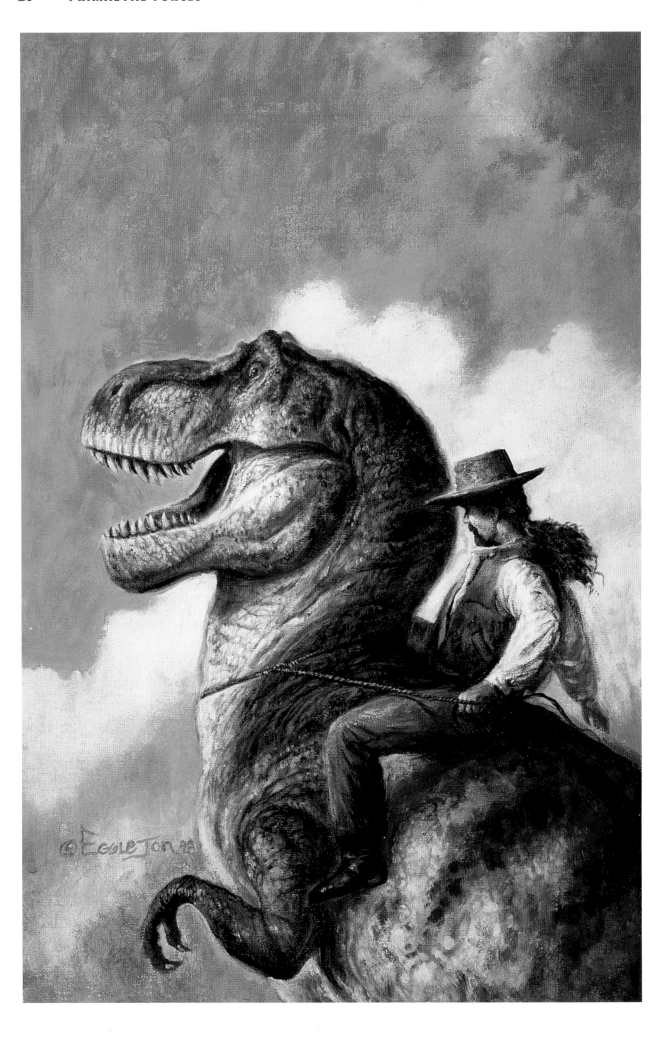

The Bone Wars, 1998 (right)
66 x 50 cm (26 x 20 in)
Acrylics on canvas
Cover for novel by Brett Davis,
Baen Books
This was a great book in which aliens and cowboys become mixed up with dinosaurs. In this scene, one such cowboy is trying to "break" a wild Monoclonius, a small ceratopsian dinosaur. I wanted a real Fredrick Remington feel to the piece because he's a Western artist whose work I admire greatly.

Two Tiny Claws: Bone Wars II, 1998 (facing page)
56 x 30 cm (22 x 12 in)
Acrylics on canvas
Cover for novel by Brett Davis,
Baen Books
The sequel to *The Bone Wars* has more dinosaurs and aliens. This time, someone tries to wrangle a Tyrannosaurus Rex. So, for fun, I also put myself (yes that's me, ponytail and all) on the dinosaur's back. Considering it's a T-Rex, a great deal of caution would be needed if one tried this in real life. As a tribute to Remington, I even signed my name with the "t" the way he did it.

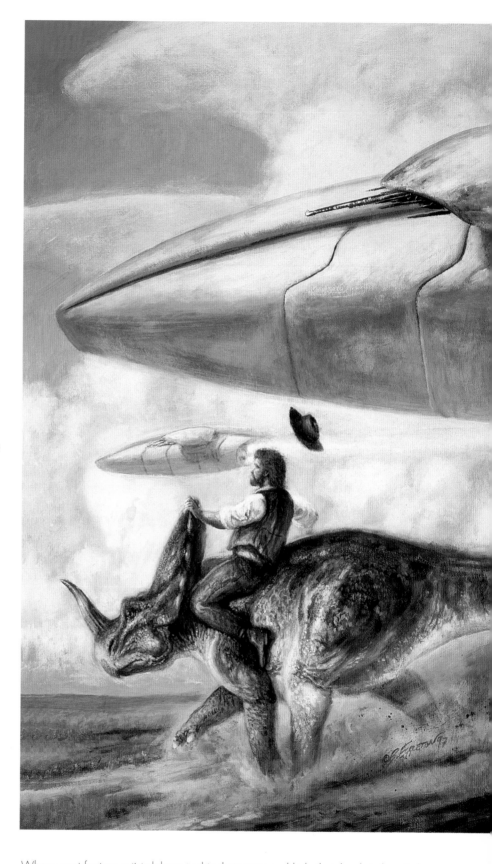

Where most fantasy artists labour to thin their paint and hide their brushstrokes, Bob lays it on ever thicker: "I've become very suspicious of 'uncharacteristic' painting. It somehow seems faked – even in some of my own works – without the sheer variety of texture of a brushstroke. I love to be able to see where a painter has really worked the paint into the canvas. I get suspicious when art is too organized, but there are exceptions like Alma Tadema with his really luscious classical fantasies."

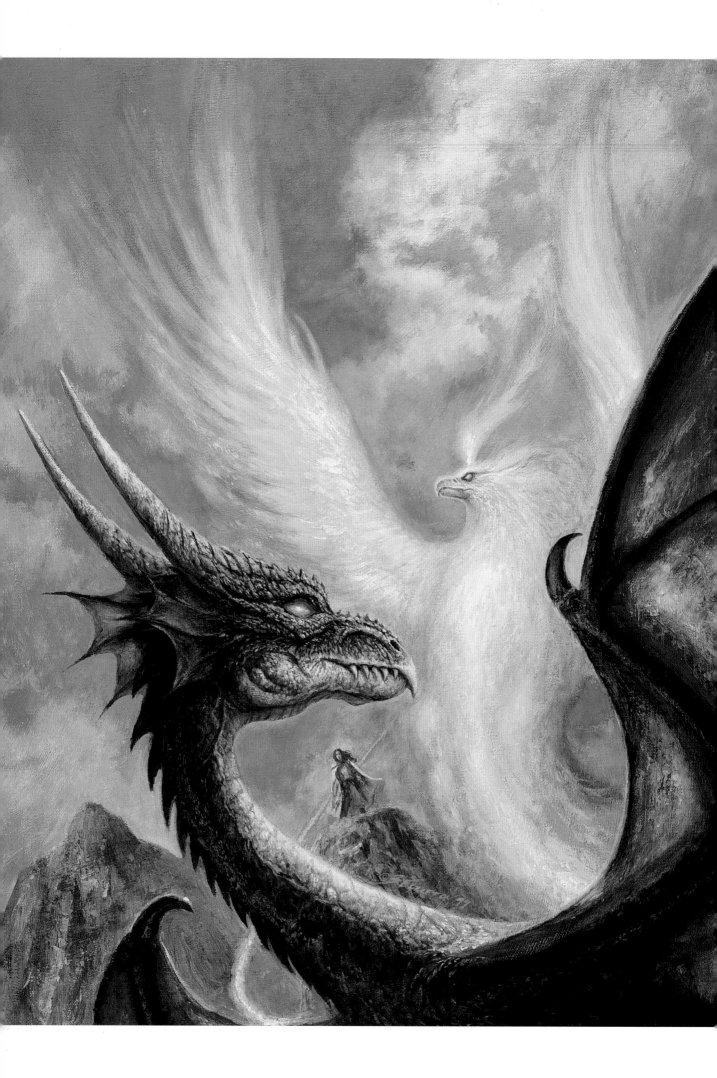

There were Giants in the Earth

When the Book of Genesis talks of the time when there were "giants in the Earth", people often take them to be dinosaurs or other monsters. But the Book of Enoch and other apocryphal writings show that the giants were, in fact, supposed to be the offspring of angels and humans, and their unruliness was one of the main causes of the Deluge. In the past few decades, a whole new mythology has sprung up around these angels, who are said to have been sent from heaven to teach early humans the arts of civilization. They have since been recast as aliens who tinkered with our DNA and taught us the rudiments of technology and so on.

Either way, the quote is apt for Bob's paintings, which catapult us from the remotest past on Earth to the farthest future in other galaxies, taking in many totally imaginary realms along the way.

Dragon & Phoenix, 1999
(facing page)
60 x 46 cm (24 x 18 in)
Acrylics on canvas
Cover for novel by Joanne Bertin, Tor Books/Earthlight (UK)
The sequel to *The Last Dragonlord* has the same design as the earlier dragon, but this time joined by a phoenix. Is the phoenix friend or foe? The cover was designed to ask such questions, so the reader will drawn to pick up the book and find out.

Magical Crystal, 1995 (right)
60 x 36 cm (24 x 14 in)
Acrylics on board
Book cover, HarperCollins
This novel was based on the popular card game "Magic: The Gathering" (*see page 24*). I was given a fair amount of art direction for this commission. The painting had to show certain elements from the book, including ruins, a desert, a robed hero and a pulsating crystal conducting energy into the hand of the hero. It all worked. I tried a lot of very painterly effects, with the image not being as tight as it may appear.

Fire Horse, 1996 *(left)*
32 x 20 cm (13 x 8 in)
Acrylics on board
Game card, "Magic: The Gathering"
"Magic: The Gathering" is a
phenomenally successful fantasy card
game played worldwide by thousands
of people, in tournaments and various
other contests. I was recruited to do a
whole bunch of cards for the game.
This was one of the concepts I liked
doing most: a horse literally made from
molten fire and magma. It came
together very quickly and has been a
very popular card. Many are mailed to
me from a dozen countries, to be
signed and returned. It's a great
feeling to know my work is touching so
many people's lives in far away places!

The Ice Dragon, 1999 *(left)*
46 x 28 cm (18 x 11 in)
Watercolours on board
Book cover, Baen Books
I did this for a book that involved giant
flying reptiles called Ice Dragons. I just
love dragons (as if you couldn't tell).
It was also my first watercolour media
paperback cover art.

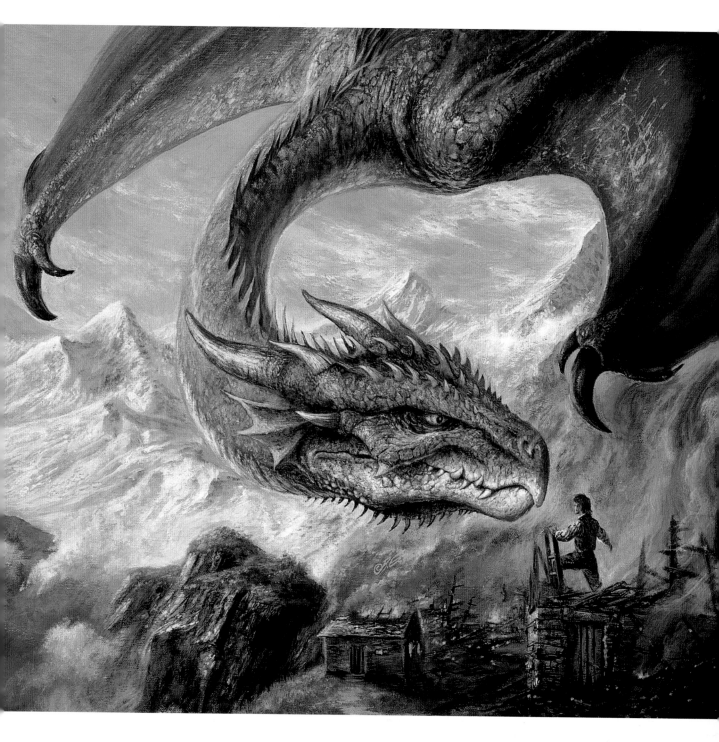

Dragon Weather, 1999

50 x 75 cm (20 x 30 in)
Acrylics on canvas board
Cover for *Dragon Weather* by
Lawrence Watt-Evans, Tor Books
Sometimes you really do get what you
wish for. I wanted to be known more
for my dragons than anything else. So
the time came when I found myself
getting a lot of "dragon" jobs, like this
one. The editor wanted "a huge green
dragon hanging over a small boy with
a burnt-out village around him". And
so I was able to do exactly that and
have a lot of fun with the techniques.
I actually scratched out areas of lighter
colour on the skin of the dragon's wing
to give it texture. It's very, very loose
when you look at it closely, but that's
how I am best at painting – standing
back, looking at the piece and
stabbing at it with a brush.

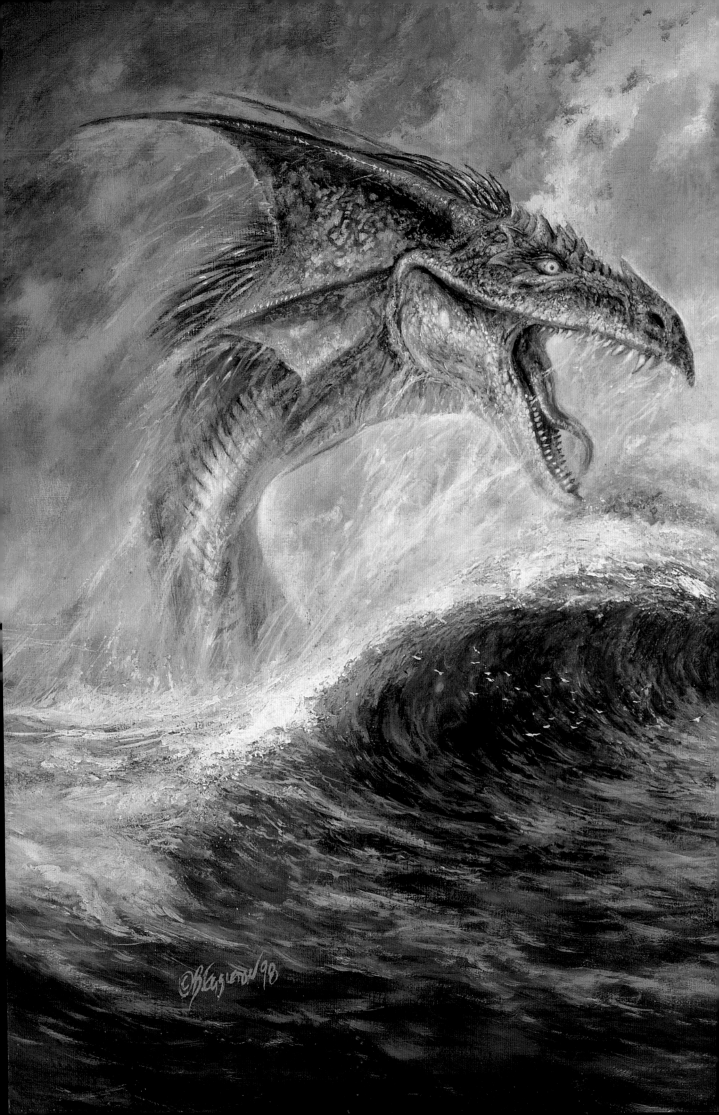

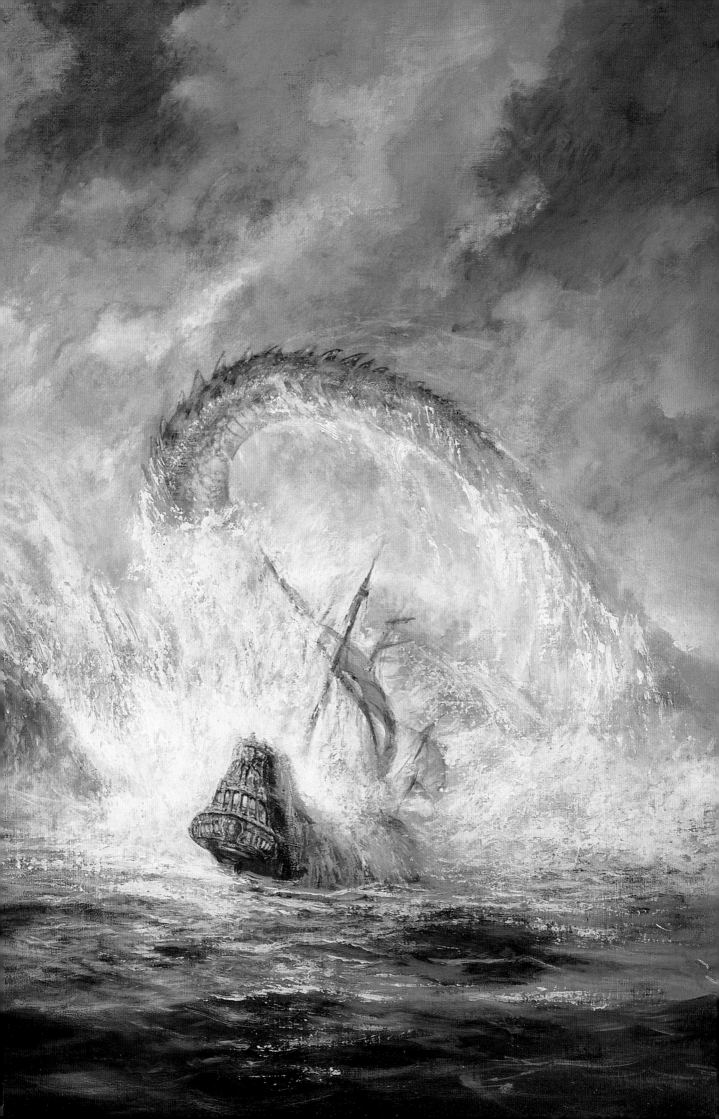

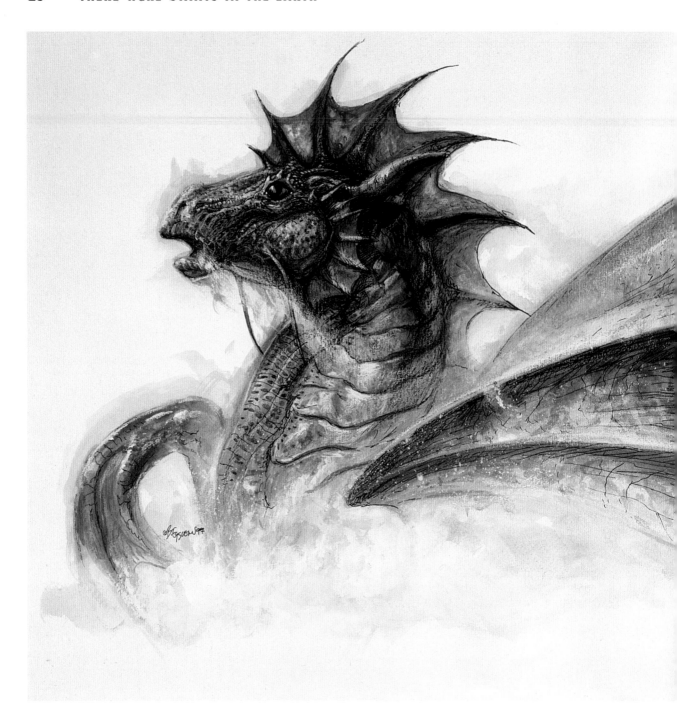

The Devil and the Deep Blue Sea, 1998 *(previous pages)*
60 x 90 cm (24 x 36 in)
Acrylics on canvas mounted on wood
Private work
This was originally slated for *The Book of Sea Monsters*, but a number of things happened. It wasn't quite finished, and I couldn't make it work well enough with Nigel's text – the original thought was to make this one "Leviathan". So I finished it after the book went to press, figuring it would have its day some other time. I still

wasn't happy with it. I was not sure what was going on, the original had a castle on an island in place of the ship and two waterspouts gushing from the monster's head. I put the painting away for about a year. On pulling it out for this book, I knew exactly what the problem was. The island/castle had to go, as did the waterspouts. They were interesting ideas, but having a ship seemed somehow more realistic. So I sanded off the castle and island, and within hours had reworked it into the drowned ship you see. This

was an instant dramatic improvement! Altering a painting like this happened all the time, I found, – the old masters, Turner, Degas, Monet, would often rework something over another earlier image. I did laugh, however, thinking that perhaps in a century or so, if I should be remembered that long, art experts using computer technology may find my earlier abandoned images under all those layers of paint, and debate among themselves what major event in my life prompted me to make the change!

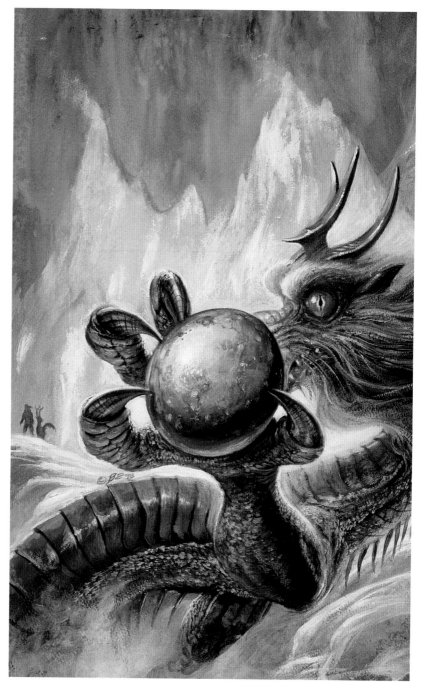

Merhorse, 1997 *(above)*

38 x 50 cm (15 x 20 in)

Pen-and-ink and watercolour

Illustration from *The Book of Sea Monsters*, Paper Tiger

Another "let's have a second look" piece. It was reproduced quite small and insignificantly in the original book, but caught a lot of attention and even found an immediate buyer. Because of this, I decided to have it printed somewhat larger here so everyone can have a closer look.

Dragonne's Eg, 1998 *(above)*

50 x 30 cm (20 x 12 in)

Acrylics on board

Cover for novel by Mary Brown, Baen Books

A fun book with an irresistible idea: to paint not a Western dragon but an Eastern one, like a Chinese dragon.

The story was sort of an "Indiana Jones" adventure, in that it involves an international romp to return a small dragon's egg to its rightful owners. Doing all the really great rainbow colours on the dragon was especially fun, as was the concept showing the mysterious "Eg" in question.

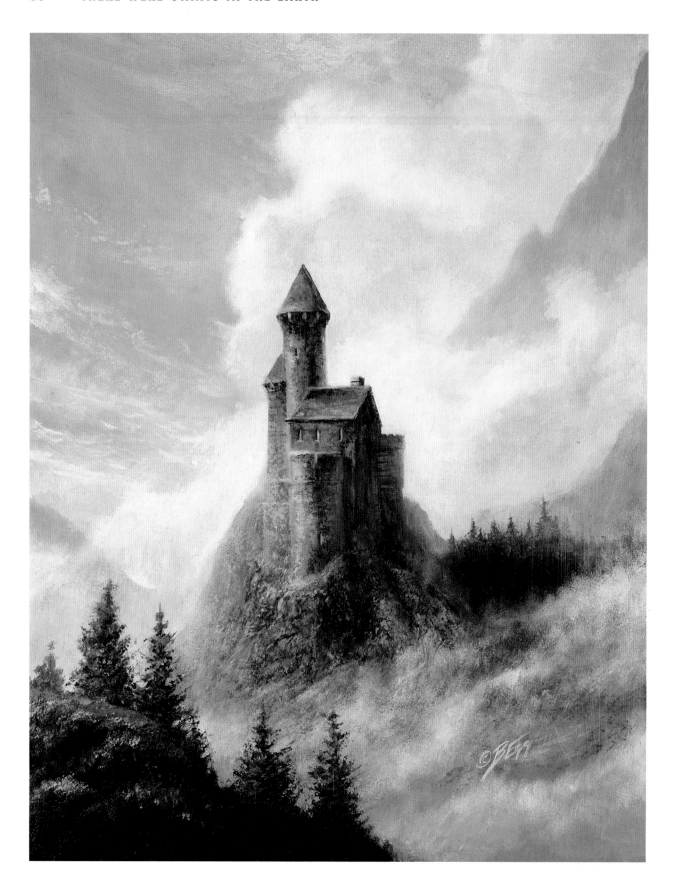

Castle in the Clouds, 1999
50 x 38 cm (20 x 15 in)
Acrylics on Whatman board
Private work
This painting was done for the sheer love of it. I think I was on a castle kick at the time. I wanted to paint standing as far away as I could from the piece and still produce a fairly detailed image. I painted mostly from imagination, looking for something bright and romantic.

The False House, 1999

50 x 76 cm (20 x 30 in)

Acrylics on canvas

Cover for novel by James Stoddard, Warner Books

The sequel to *The High House* (*see* page 56) has our hero encountering another "house" 10 years later. In this case, the publisher didn't want any more dragons simply because that would make it look too much like the first book. So, there were these strange, ghostly cat-like creatures. And it took place, to a great extent, in snow. In the end, the house sort of de-materializes away to another dimension. I was aiming for a feeling of frenetic energy. Books like this are terrific because they bring out some of my best technical feats. I painted this all in dry-brush on canvas, which gave a rich feeling as the brush moved over the rough surface.

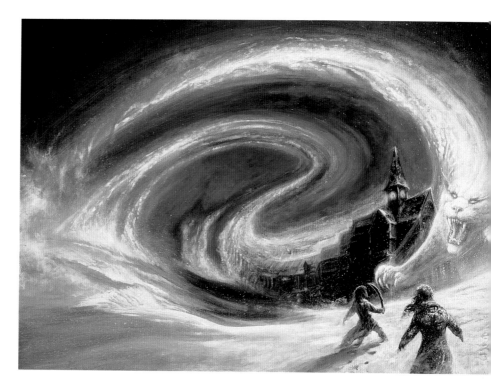

Pegasus, 1982

50 x 38 cm (20 x 15 in)

Coloured inks and pen-and-ink on board

Private work

Here is a rare item. One of my VERY first fantasy paintings which I did way back when I was starting off, to show people what I could do. I sold the original and then, while preparing work for this book, came across the negative and decided to include it. The painting still holds up, but in retrospect, like all artists, I see everything that's wrong with it and only hope it shows how much I have improved over these 17 years...

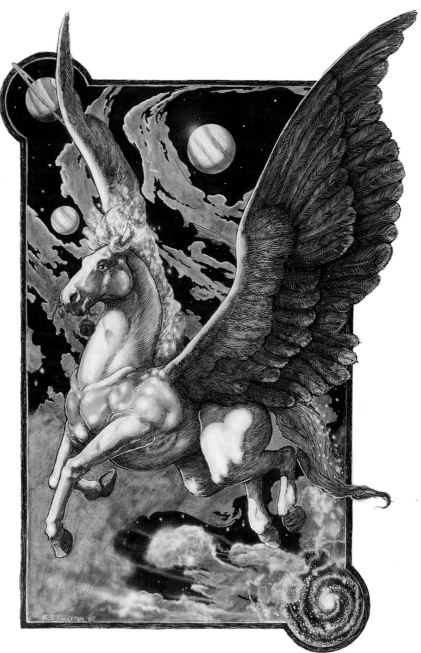

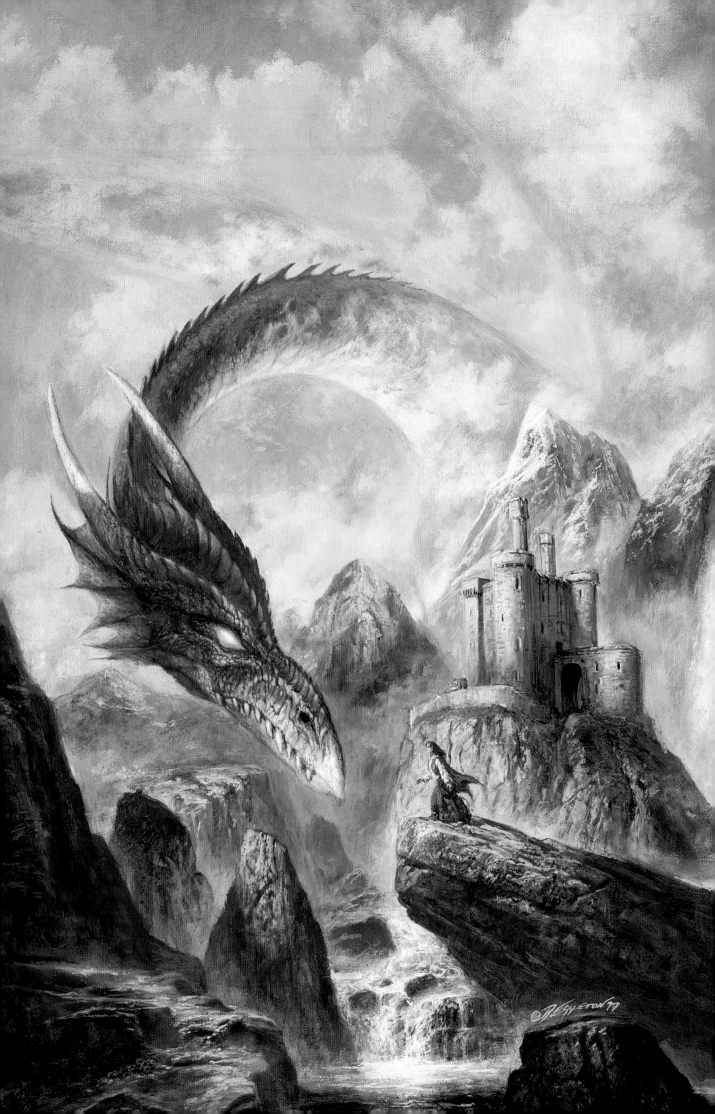

The Last Dragonlord, 1997

(facing page)

60 x 46 cm (24 x 18 in)

Acrylics on canvas

Cover for novel by Joanne Bertin,
Tor Books/Earthlight (UK)

This was a first novel by a young
author. It's a wonderful book full of
imagery and a fresh take on dragons
that could only be achieved by such a
fresh, new author. It also marked a
new phase for me – a more "painted"
look with no airbrush at all, and a
more direct approach to fantasy art.
The publisher and author liked the
cover a lot, and I ended up doing the
sequel, picking up several more
"dragon" commissions as a result.

Scales of Justice, 1997 *(right)*

66 x 33 cm (26 x 13 in)

Acrylics on canvas

Cover for novel by Daniel Hood,
Ace Books

This was the fourth in a series of books
and here we have Fanuihl, the tiny but
fastidious dragon who is a wizard's
servant. The requirement was that he
be reading from an old book with the
"Scales of Justice" somewhere in it. For
a bit of fun, I also put on the far page
some Japanese writing that spells out
"Godzilla, Rodan and Ghidrah". The
collector who proudly owns this
painting had a Japanese houseguest
who spotted my little trick at once!

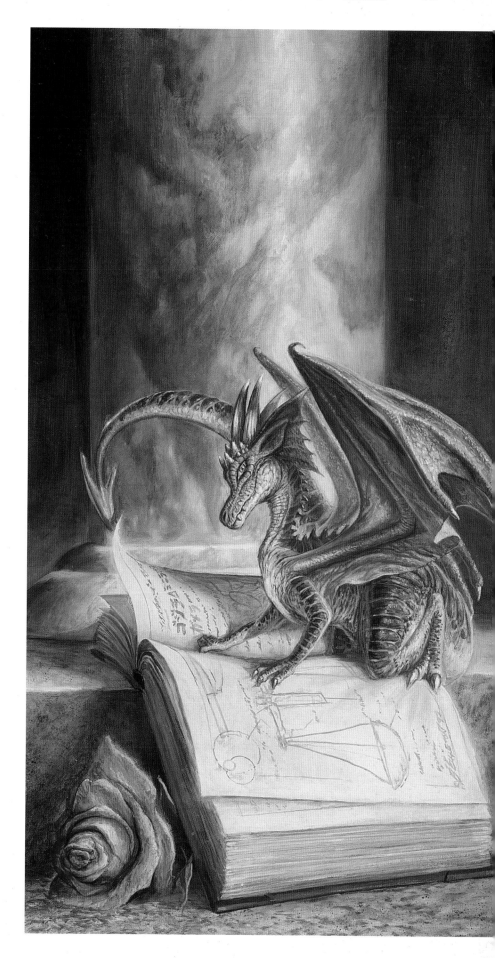

Dragonhenge – The Ring of Stone, 1999

28 x 36 cm (11 x 14 in)
Pencil
As the old saying goes: "And that's another story waiting to be told". Dragonhenge is an idea for a story,

a springboard for a series of paintings and drawings dealing with intelligent races of dragons, all taking place in man's past. I like pencil work a lot. The pencil may well be the most underrated medium available to an artist. It's the most basic tool for

translating an idea from your mind onto paper. Unfortunately, commercial clients all too often view pencil work as vague and unfinished. I could not disagree more...Look for Dragonhenge sometime in the near future as an entire book.

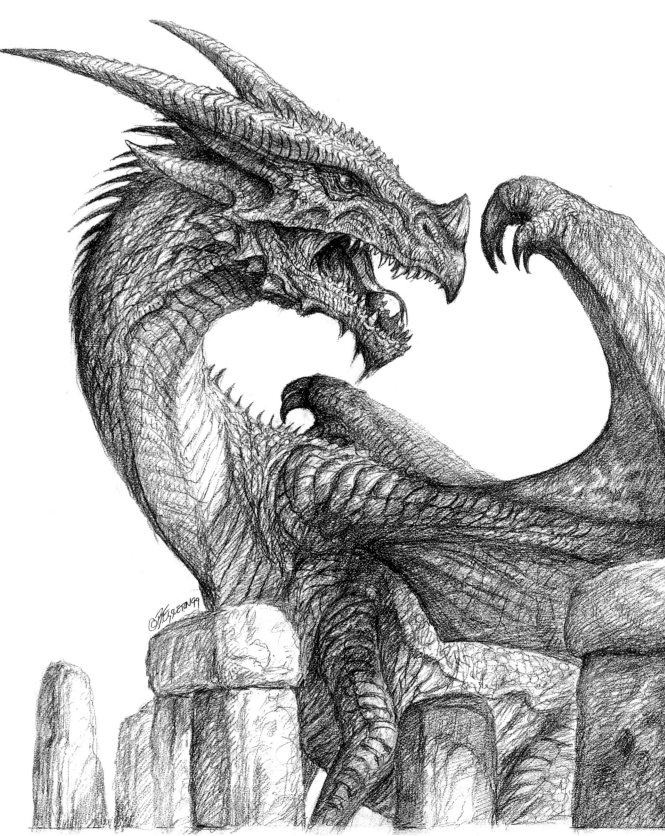

It may, perhaps, be obvious that Bob Eggleton loves painting dinosaurs. He also loves playing with the idea of how they might have evolved into beings with speech and technology like us, if they had been spared extinction. And then there are dragons, which are a different matter altogether.

For Bob, the pleasure in painting dragons is that they are more than dinosaurs. They are supremely colourful, elegant, ornamental and, according to many tales, intelligent. They are also a great fun for an illustrator because their form is not strictly defined. The broad outlines are there, but within them, there is plenty of room for improvization. Bob's "genuine feeling" about dragons is that it would be fun to believe that some dinosaurs survived into the Middle Ages to plague errant knights in shining armour. It would be nice to imagine that the countless medieval songs, poems and romances about dragons were based on truth. But in the absence of any concrete evidence he also, however reluctantly, believes it highly unlikely.

While sketching and photographing Komodo Dragons in Australia, he could see how tales of these beasts might easily have grown with the telling. And in fact, many Chinese do believe them to be true dragons in an early stage of life. The other half of evidence of the existence of dragons was the large hoards of dinosaur bones in China that, until one hundred or so years ago, had been famous for centuries for being dragon remains. So dinosaurs and Komodo Dragons between them have contributed much to the mythical dragon, but there is also a magical aura about them that is all their own.

Bob likes to use a "wildlife" approach to his dragons, treating them as real creatures. One of his heroes is David Shepherd, famous for his paintings of charging elephants and lions that look as if they were painted on the spot. Which some have been of course, more or less. Bob has a shelf full of Shepherd's books and has studied his painting techniques closely.

The Familiar Dragon, 1997
(above)
50 x 36 cm (20 x 14 in)
Acrylics on canvas
Cover for anthology of novels by
Daniel Hood, Science Fiction
Book Club
Another portrait of Fanuihl, the wizard's diminutive helper from "Scales of Justice" (see page 33). The idea was to show a storybook-like picture of this little dragon, something that best represents the first three books of the series.

North-eastern Field Dragon, 1994 *(left)*

60 x 46 cm (24 x 18 in)

Acrylics on watercolour board

Illustration for a short story by Tanya Huff. Marion Zimmer Bradley's *Fantasy* Magazine

I originally presented this piece in my first collection *Alien Horizons*, but felt it was rather overlooked. I wanted an almost "wildlife portrait" feel to this painting. I think because it has such prosaic colours, people do not pick up on it as a "fantasy" painting. Still, it's one of my favourites, with rendered areas I am still proud of.

Over the Rainbow, 1999

(facing page)

100 x 50 cm (40 x 20 in)

Oils on wood panels

Private work

My dad died in 1998 at the age of 76. His body was cremated, so in order to "put a little of him into this picture" I took a handful of his ashes and, for texture, mixed them into the white ground used to create the surface on which I painted. I came up with the idea of a castle rising high above the landscape – he always liked castles and the English countryside. I mostly used a palette knife and worked very, very fast in oils. I completed the piece in about two weeks. It went joyfully.

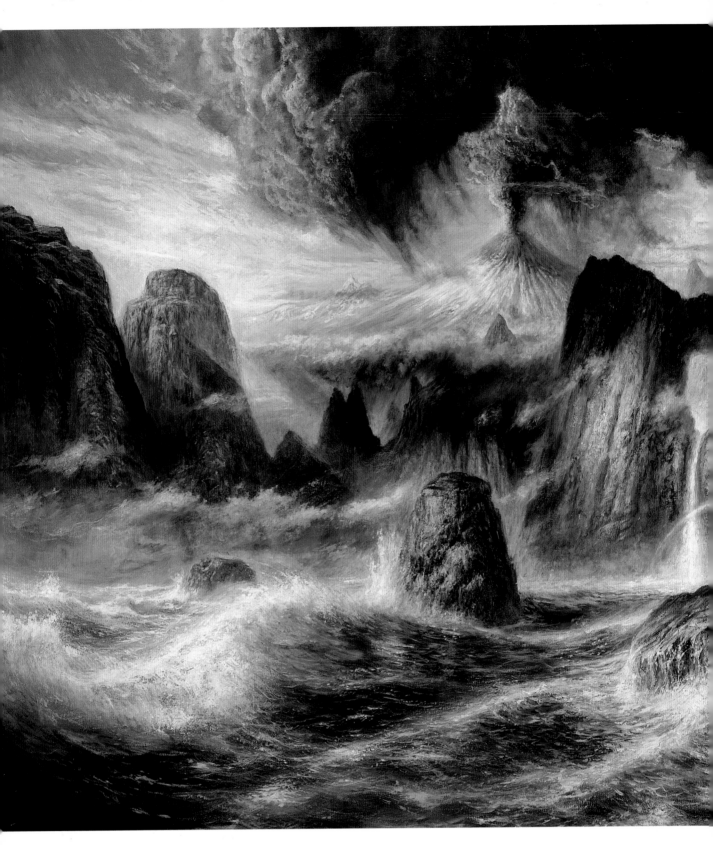

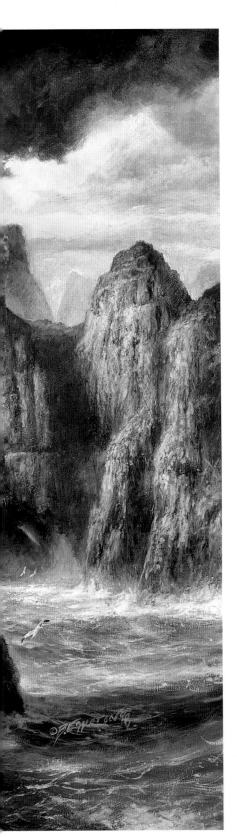

The Land of the Gods, 1998
76 x 100 cm (30 x 40 in)
Oils on canvas
Private work

This is a self-commissioned piece I had been intending to do for several years. I had ideas and sketches. Then in the middle of watching my father's terrible illness progress, seeing him getting worse and worse, I felt I had to start something that I could project myself into. So I put aside all my paying commissions (along with their deadlines) and spent a couple of weeks working this canvas feverishly. I literally trowelled on the paint with a palette knife and scraped back other layers, and glazed on thin oils over thick areas...I tried to convey the variety of emotions I was experiencing...with the rainbow part being maybe a slight glimmer of hope. My dad seemed to be in the hands of the Fates...in the Land of the Gods.

Bob Eggleton's parents have influenced his work as much as anyone, through encouraging his art from an early age and equipping him with the mental disciplines needed for professional illustration. His father was an engineer, an inventor even. His name is on the patent for laminating Teflon onto frying pans and he had a fierce passion for work throughout his life that seems to have rubbed off. He also survived the Battle of the Bulge in the Second World War, but would never talk about it. Bob's mother moved to the States in the 1950s as a "red-haired London lass" looking for adventure and has maintained her Englishness (and Bob's) by frequent trips across the Atlantic to visit the relations. Sadly his father died in 1998, a traumatic year in many ways, though it also had its bright moments.

Bob: "Death can be sobering. Being surrounded by death illustrates the importance of living in the moment and appreciating that moment. I was surrounded, in less than one year, by the shadows of death. Several friends around me died of horrendous ailments, including my own father. In 1998, he began acting oddly and seemed to be easily fatigued. Within several weeks, he was suffering from some neurological malfunction and had to be hospitalized. Soon after, it was discovered he also suffered from emphysema and lung cancer. He died within seven weeks of falling ill, from pneumonia. That he died is something that, for whatever reason, can only be known to Fate.

"After his death I felt an emptiness, a sadness than can only be experienced, not described. But death is part of life, and life goes on. His body was cremated and thus he became part of the earth again. Most of his ashes were interred in a War Veteran's Cemetery, which is just as he would have wanted. Some were scattered in the ocean. And some ashes had another destiny, which I saw the minute I held them in my hands. I was going to mix them into acrylic gesso as a base on which to create a painting. *Over The Rainbow* (see page 37) is this painting. My Dad always encouraged me to do what I wanted with my work, to turn a negative into a positive. So I knew he would like me to do something like this. The painting was a wonderful experience; I should have more like it. Not only was it a work for my own pleasure, but I could 'feel' Dad on the ends of my brushes. It was remarkable."

Greetings from Earth

Some years ago when Bob was working flat out on paperback covers, there came a point when the passion just drained out of his painting. His horizons felt cramped and he felt it was time just to follow his own imagination. So he scaled back on the commissions and began taking time just to paint whatever came to mind. At the same time he reviewed his whole attitude to art techniques and phased out the airbrush in favour of more traditional and textured media. He also started working at an easel instead of sitting hunched over a drawing board, and it has done wonders for his back. His painting has also improved because an easel forces him to stand back from the work. Bob's private works cover the whole range, but his first passion is for pure landscapes. These are mostly painted on the spot. No quick sketches and photos to be fleshed out in the comfort of his studio, Bob likes to feel the salt spray in his face while he lashes paint onto the canvas. Only the final touches are made in his studio.

Big Sur Twilight *(facing page)*
36 x 28 cm (14 x 11 in)
Oils on board

Rocks and Waves, Rhode Island *(below)*
36 x 43 cm (14 x 17 in)
Watercolours

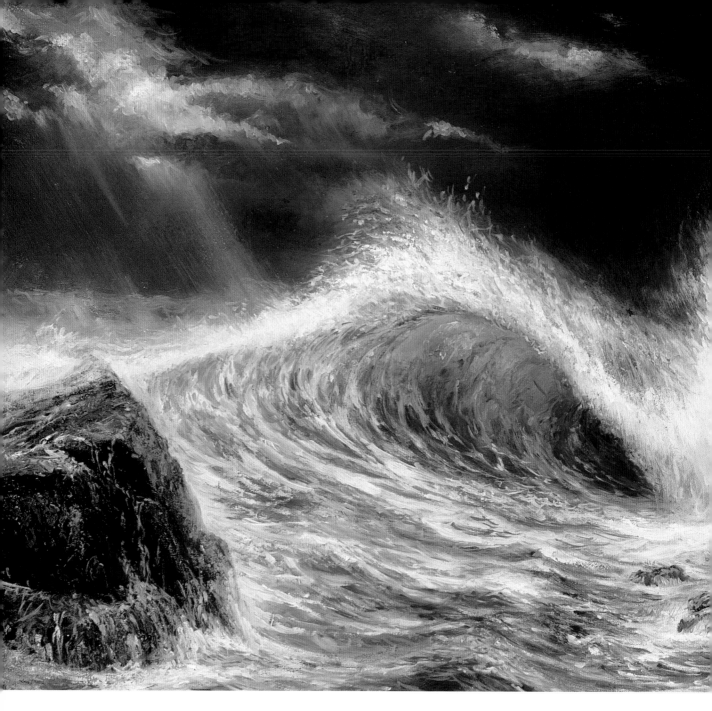

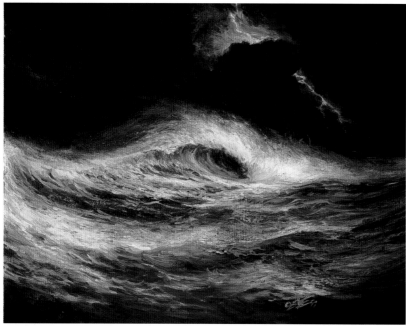

Roller *(above)*
40 x 50 cm (16 x 20 in)
Oils on board

Dark Wave *(left)*
23 x 30 cm (9 x 12 in)
Oils on board

Volcano (sketch) *(facing page, top right)*
36 x 28 cm (14 x 11 in)
Oils on board

Beavertail Surf *(facing page, bottom)*
28 x 36 cm (11 x 14 in)
Oils

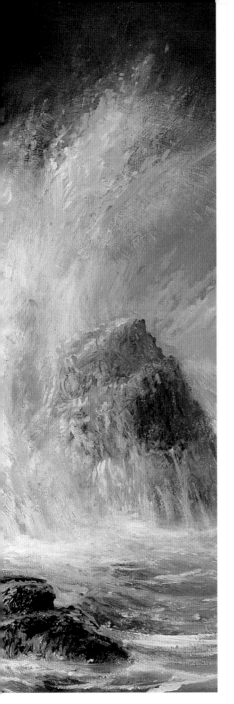

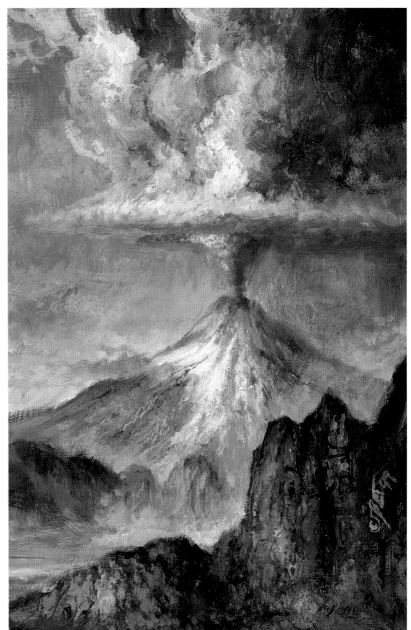

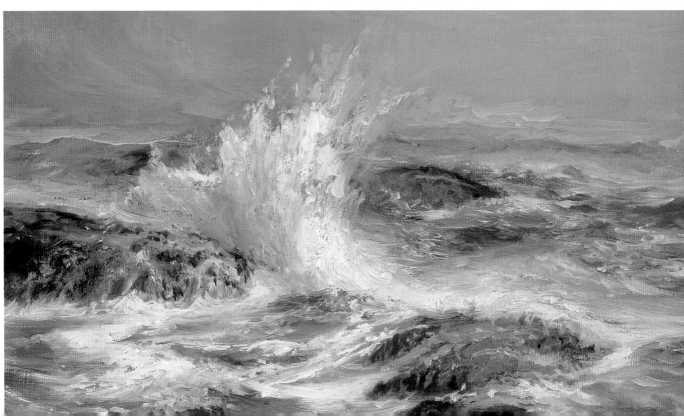

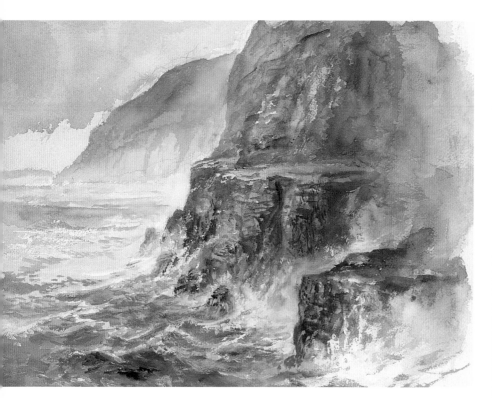

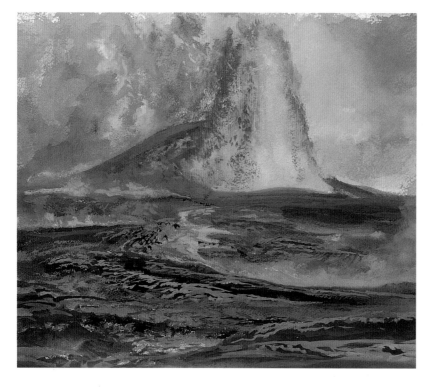

Typhoon *(above)*
28 x 36 cm (11 x 14 in)
Oils on board

Newcastle Beach (N.S.W.
Australia) *(top)*
36 x 43 cm (14 x 17 in)
Watercolours

Volcano National Park, Hawaii
(above)
36 x 43 cm (14 x 17 in)
Watercolours

Jamestown, Rhode Island
(facing page)
36 x 43 cm (14 x 17 in)
Watercolours

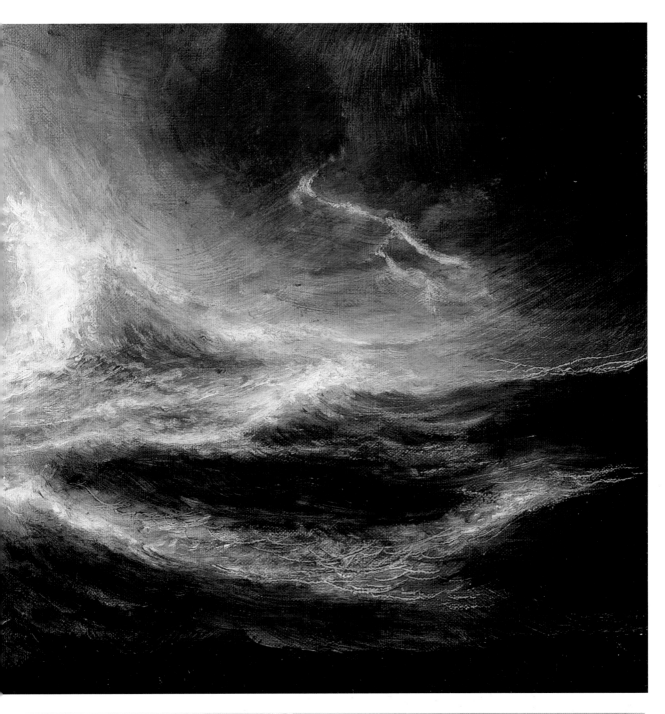

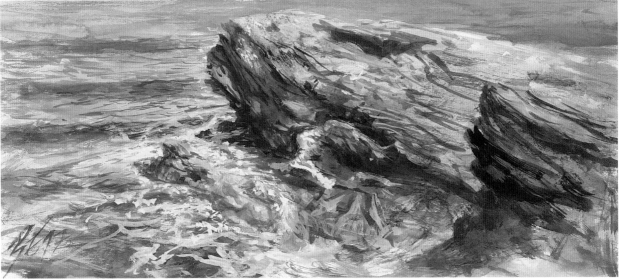

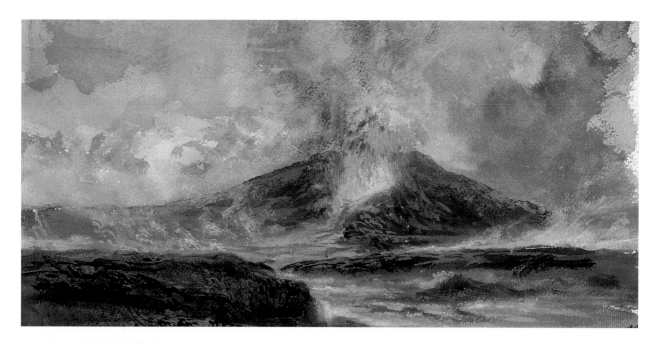

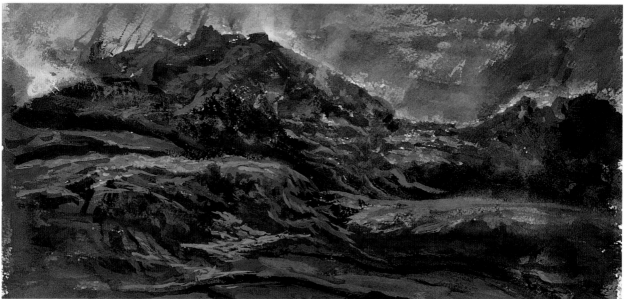

Volcano II, Hawaii *(top)*
36 x 43 cm (14 x 17 in)
Watercolours

Kileauea Iki Crater, Hawaii
(above)
36 x 43 cm (14 x 17 in)
Watercolours

Bob: "I have a real passion for land- and seascape works, it's a growing passion, the idea of painting en plein air – on location – to experience the actual colour and vibrancy of the scene. In fact, I like it MORE than I like illustrating, of late. Maybe it's my age. Science fiction fans are going to see a lot more of my landscape works. This is just a sample of what is to come."

This growing passion owes a lot, he feels, to having changed direction lately. Or rather, to having realized that there is no hard distinction between Earth and space, as it previously seemed: "It's all connected, that is kind of where I've found myself the last few years. I suddenly began to see the cosmic in what's on Earth. Our bodies contain bits of star matter, and matter anyway is made of atoms and molecules that are star systems in themselves. Many hardcore astronomical artists seem to feel stranded on Earth, forgetting that, as someone said, we are all space travellers because our planet and solar system and even galaxy are all hurtling through it. We're never really in the same place for long. Getting married is also part of this change, it's made my universe a little more centralized."

He met Marianne, who is also an artist, when she wrote to him about his first book, *Alien Horizons*. Many people do this, but this time there was a particular spark and despite living on opposite sides of the globe, romance soon developed. Finally, Bob flew to Australia a few times and Marianne flew to the States, moving there permanently in 1998 when they got married. The wedding was held in a hotel on an offshore island not far from where Bob lives, where Captain Kidd once had a mistress and is rumoured to have buried his treasure. Hundreds of treasure hunters ransack the place hopefully every year, but so far, the treasure has eluded them. In honour of the place and occasion, Bob wore a pirate's outfit.

Also there was the advice his father was fond of giving: "Diversify, diversify, diversify. Those are the three things you need to stay afloat." He also used to say that whatever Bob drew, be it space ships or whatever, he should do it as well as possible, but that he shouldn't stop there. He should draw other things as well. And that is pretty much what Bob has done. Whenever he makes a name in one field, he moves on to another, not always to the pleasure of his fans. There are people who love his spacescapes and can't stand his dragons, for example, but for Bob they are just different aspects of what he wants to do.

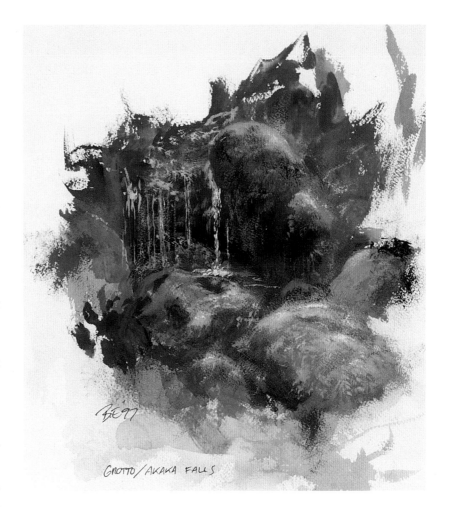

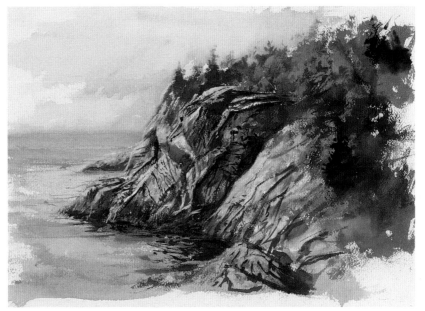

Grotto at Akaka Falls, Hawaii
(top)
36 x 43 cm (14 x 17 in)
Watercolours

Cove, Rhode Island (above)
36 x 43 cm (14 x 17 in)
Watercolours

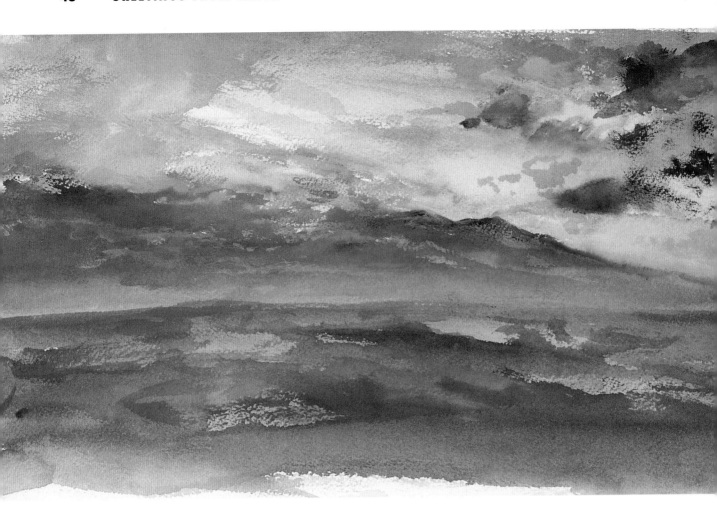

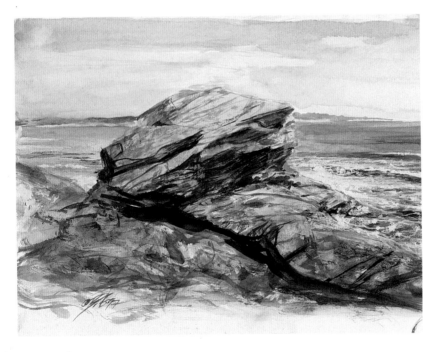

Hilo Sunset, Hawaii *(above)*
36 x 43 cm (14 x 17 in)
Watercolours

Rocks at Jamestown *(left)*
36 x 43 cm (14 x 17 in)
Watercolours

Honolulu Rainclouds *(facing
page, above)*
36 x 43 cm (14 x 17 in)
Watercolours

Kona Twilight, Hawaii *(facing
page, right)*
36 x 43 cm (14 x 17 in)
Watercolours

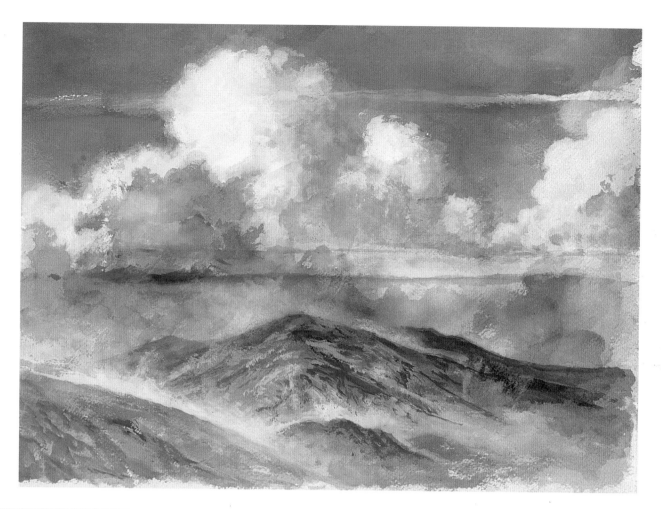

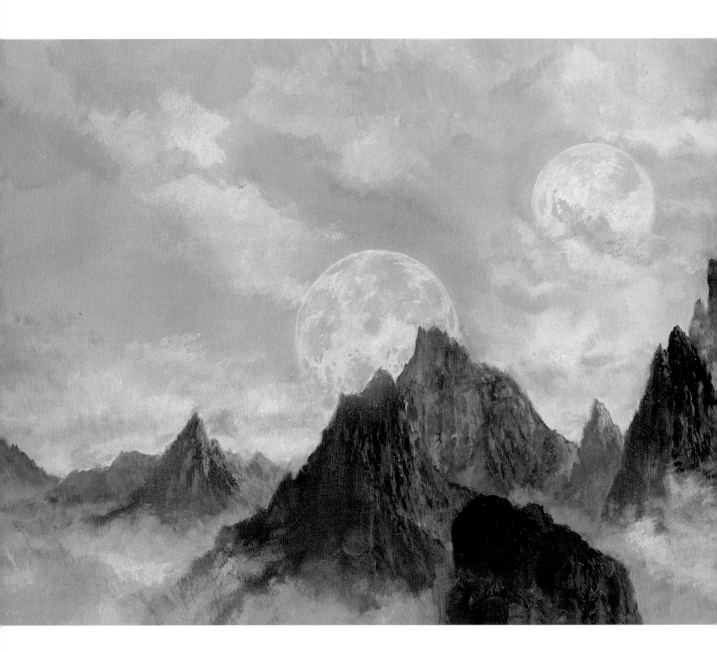

Cthulhu 2000, 1995
26 x 66 cm (10 x 26 in)
Acrylics on board
Cover for book edited by Jim Turner,
Arkham House
This was sheer joy to produce, and
perhaps my best Cthuhlu (pronounced
"Cloo-Loo") painting ever, although
there is, as always, some disagreement

over that. The late Jim Turner was a
friend of mine and we had a working
relationship that I very much treasured.
He died suddenly, at too young an
age, so whenever I see this painting, I
think fondly of Jim and how much he
enjoyed it; and I remember how he
published books simply for the pure
love of it.

And Darkness Fell Across the Land

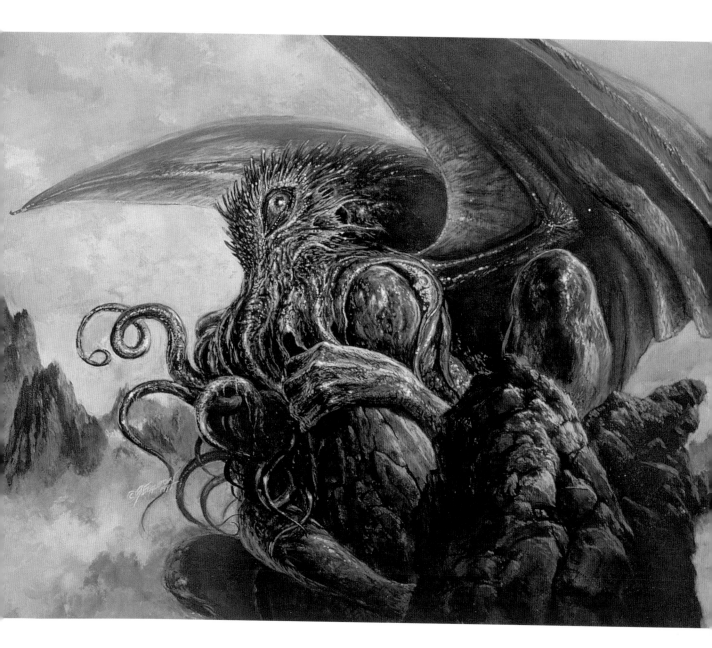

*L*ike most of us, Bob has had black moments in his life, but they rarely have much to do with his horror paintings. He generally has a lot of fun with them and thinks the horror is often taken far too seriously. He does occasionally get very dark thoughts, and may even work them into a horror painting, but by the end he is usually having so much fun with it that he has forgotten where it all started. For instance, *The Relatives* (page 58–59) was an idea that popped fully fledged into his head and was hilarious from the outset, although it gives many people the creeps. Of course, it may be that Bob's relations are a tad different from yours or mine...

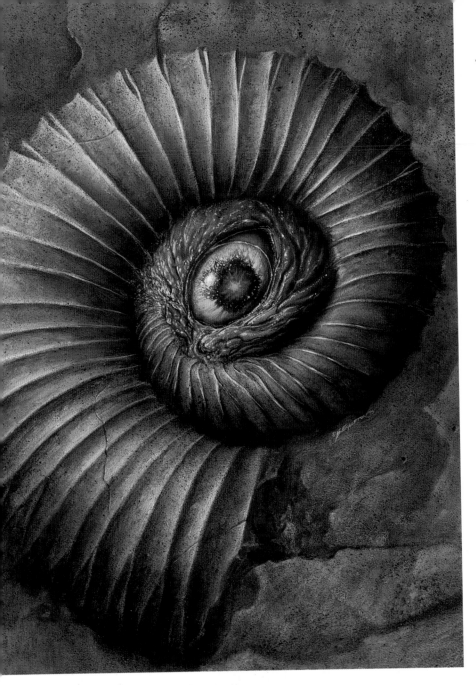

Titus Crow, 1997 *(left)*
56 x 44 cm (22 x 17 in)
Acrylics on board
Cover for novel by Brian Lumley,
Tor Books
Brian Lumley, like myself, is a big fan
of H.P. Lovecraft. He even once wrote
a series of stories involving Lovecraft's
dreaded creation Cthuhlu. In this case
I wanted something that hinted at the
prehistoric past, so I did the ammonite
shell, fossilized, and with the seething
eye in the centre, to capture the feel
of the book which, comprising over
three volumes, is, in fact, several
novels in one.

Probably the main thing people misunderstand about Bob's macabre horror pieces is that for him a skull, for instance, is not particularly horrific in itself. Far scarier are the invisible bugs and viruses that unexpectedly ravage the world from time to time. Also he does have a very dark sense of humour at times that he calls his "bring out your dead" humour, as in *Monty Python and the Holy Grail*. This is shared by many in the horror genre, authors, artists and publishers alike. Some do maintain a sort of Edgar Allen Poe approach of dead gloomy seriousness, but the cathartic black humour of horror is what Bob goes for.

Much of his favourite horror work has been done for Arkham House, the quality publishers set up by August Derleth to keep H.P. Lovecraft's books in print. They have since gone on to publish many other horror writers right up to current masters like Ramsey Campbell and Stephen King. Bob had a great relationship with his editor there, Jim Turner. Beyond gently pointing out a way forward, Turner would leave him entirely to his own devices, which is what every artist really wants. When Turner left to form his own company, Golden Gryphon Press, Bob followed and produced more of his own favourite work.

Darkness Descending, 1999
(facing page)
46 x 60 cm (18 x 24 in)
Acrylics on canvas
Cover for novel by Harry Turtledove,
Tor Books/Earthlight (UK)
This was the second in a series of
books in which Turtledove spins the
tale of a war fought with magic
instead of technology, and dragons
and ancient animals. In this case, the
dragons are battling a Basilisaurus
whose rider works the beast like a
submarine (note torpedoes). It's known
as a "Leviathan" in this scenario.

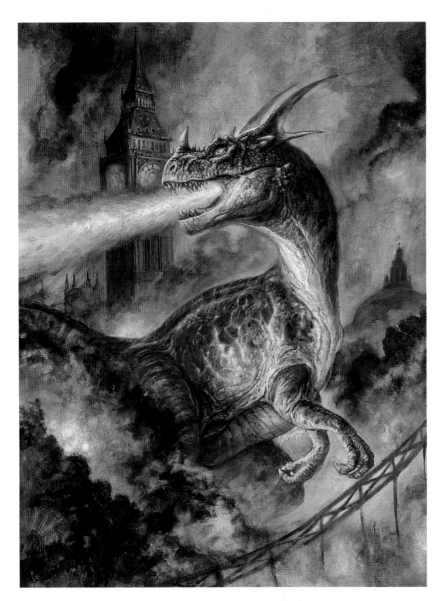

Gorgzillicus, 1997 *(left)*
50 x 40 cm (20 x 16 in)
Acrylics on canvas
WFC/Titan Books (UK)/Paper Tiger (UK)

In 1997, I was Artist Guest of Honour at the World Fantasy Convention in London, England. Steve Jones, well-known editor and all-round monster fanatic (as I am) asked me to do a "giant creature like Godzilla destroying London" for the programme cover. The idea was too good to resist and I so enjoyed doing it that I decided to make it into a character for a mini-story in *The Book of Sea Monsters*. It was fun combining the attributes of many different monsters to make a whole new one. The dark lesson behind such fictional creations is that when man tinkers with nature, there is always a risk of monsters being unleashed. Maybe not as obviously terrifying as this, but there surely is a frightening risk of creating a new virus or microbe that could wipe out much of humankind.

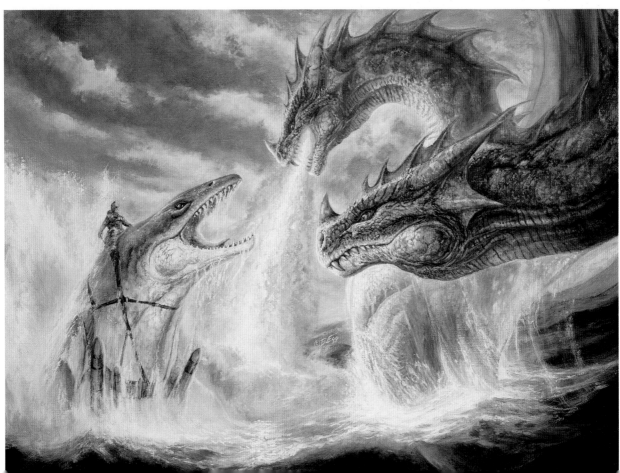

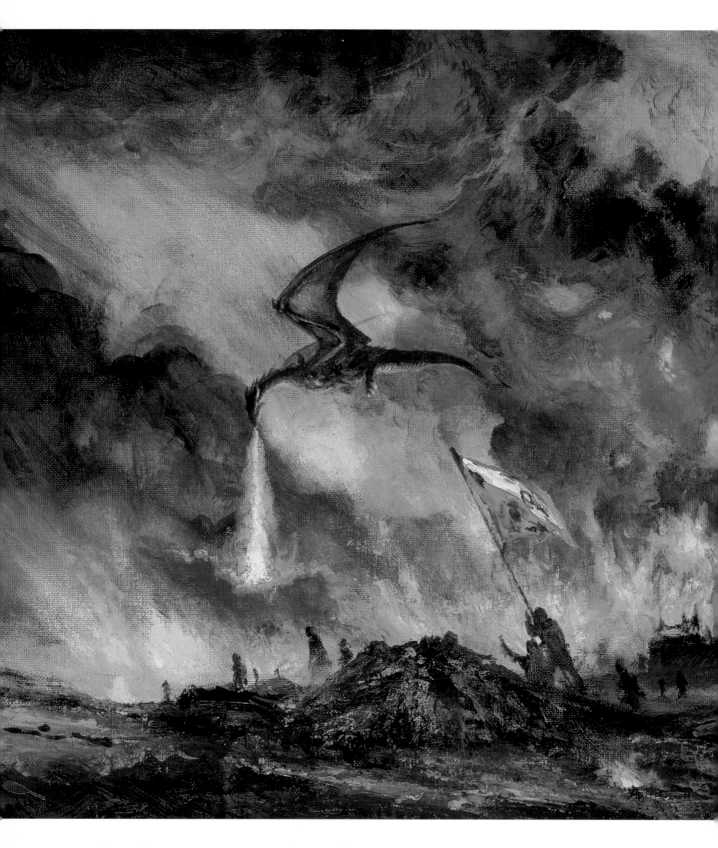

Into the Darkness, 1998
30 x 76 cm (12 x 30 in)
Acrylics on canvas
Cover for novel by Harry Turtledove,
Tor Books/Earthlight (UK)
Imagine if World War II had taken

place in a different reality where magic
and mythical beasts were used in
combat. Harry Turtledove is a master
of the new subgenre of sf & fantasy –
Alternate History. What I tried to
capture was the sheer ferocity of war,

but one fought by flying dragons and
"tanks" which are, in fact, woolly rhinos.
It was joy for me to do this. I painted
much of it with a palette knife, scraping
on paint with the same ferocity with
which the battle was being fought.

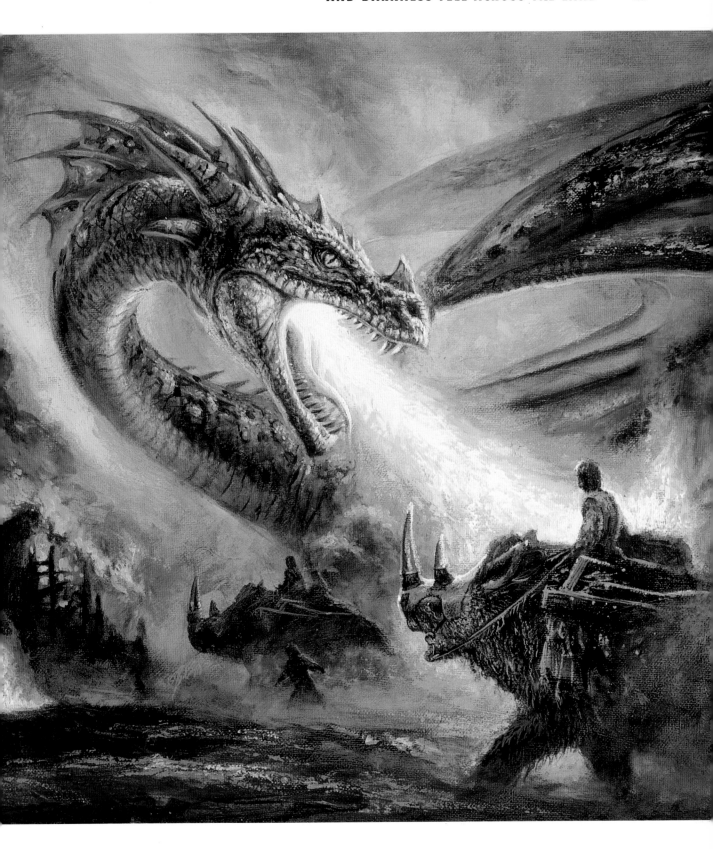

The High House, 1997 *(below)*
56 x 72 cm (22 x 28 in)
Acrylics on watercolour board
Cover for novel by James Stoddard,
Warner Books
Stoddard is a new author who wrote
one of the most highly acclaimed first
novels of the year. The house is a vast
structure and living inside is a huge,
intelligent dragon that has been many
creatures to many cultures. The hero, a
nine-year-old boy, must climb the side
of this huge house to get inside. The
dragon is literally part of the house, so
I wanted to convey this by making the
house look like the dragon and having
parts of the dragon morph into the
building. The clock tower, if you look
at it, forms the dragon's "tail"; the
various points and gables are spikes;
the shingles are his scales; the clouds
are his fiery breath and so on. I also
wanted an Escher-like feel overall, one
of false horizons and weird perspectives.

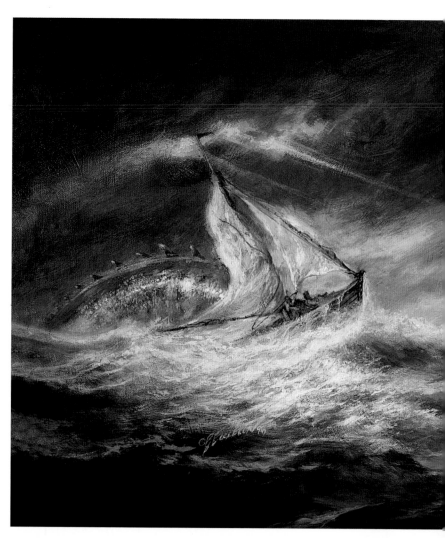

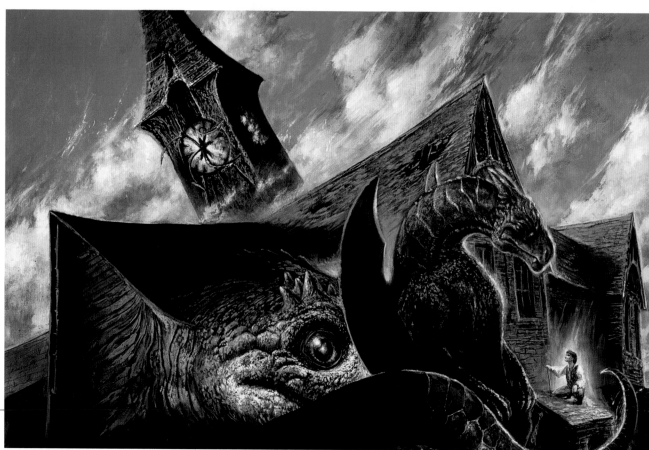

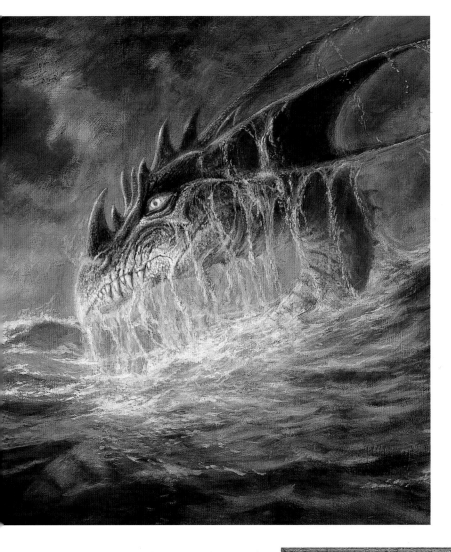

Head on a Hook, 1997 *(below)*
30 x 23 cm (12 x 9 in)
Acrylics on canvas with frame
Private work
I did this little painting as a lark. It was just a nice series of splotches that ended up looking great, so I started working them up to form this desiccated head. In a turn of dark humour, I stuck a "display hook" in the top, sort of like a Christmas ornament. The frame I picked up for $5 and looks so horrible that they go together perfectly. When the Collins & Brown Sales Director, Terry Shaughnessy, saw the original at the 1997 World Fantasy Convention in London, it gave him the genuine creeps, so here you are Terry, this is dedicated to you.

The Sea Serpent, 1997 *(above)*
30 x 72 cm (12 x 28 in)
Acrylics on canvas
Book cover, Paper Tiger
This was the wraparound cover to *The Book of Sea Monsters* by myself and Nigel. So, for those who have that book, here's a chance to see the picture whole without having to flatten the covers and strain the binding.

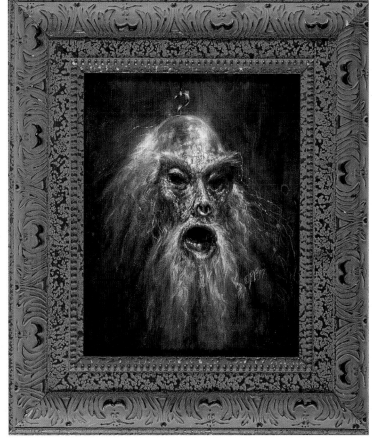

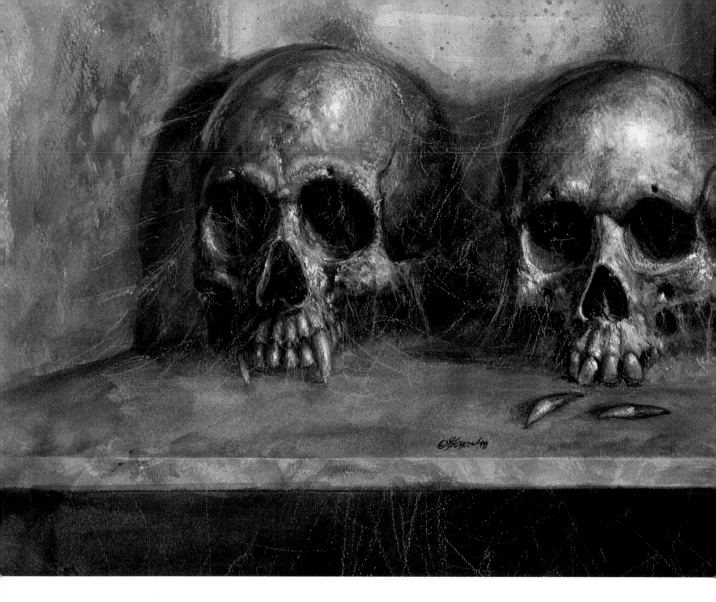

The Relatives, 1998

40 x 50 cm (16 x 20 in)
Watercolours on watercolour paper
Cover for anthology by Brian Lumley,
Fedogan & Bremer

The great part of working with "small"
press publishers is they let you go and
do whatever you want to do. In this
case, it was a Brian Lumley collection
called *Coven of Vampires*. I saw this
as a simple idea: skulls, and, to
indulge my dark humour, I decided on
two of the skulls the vampire incisors
would be yanked out, something done
by a very scared person who is taking
no chances on their regeneration. But,
what about the one whose fangs they
DIDN'T yank out...?

Most of Bob's paintings have been commissioned, especially for book and
magazine covers. This means working to some extent within limits set by others. This
has rarely been a problem and most of his pictures have managed to satisfy the
client and himself equally. Not all commissions are as much fun as *The Relatives*
(above), though, and he has met a growing trend in publishing for Art Directors to
be replaced by committees of marketing people who more or less dictate to the artist
what they should paint.

This has taken a lot of the fun out of cover illustration, so Bob finds himself getting
choosier about the jobs he takes on. Instead, he often commissions himself to do
pictures he feels a real urge to do, without any restraints. In the last year, he has
done many such pieces, some of them published in this book for the first time.
Everything goes in cycles though and he hopes soon to be able to return to book
jacket illustration in a big way.

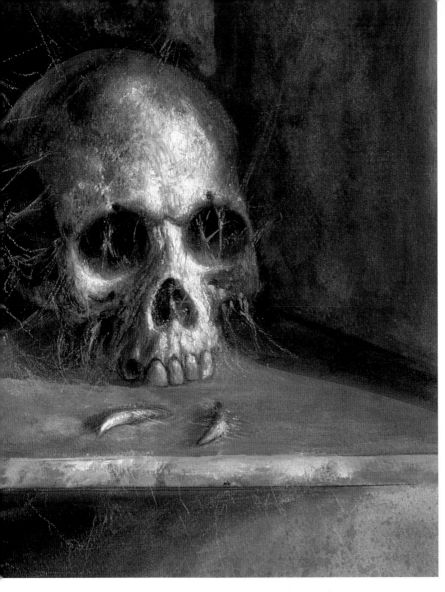

Necroscope: Invaders, 1998

(below)

36 x 28 cm (14 x 11 in)

Acrylics on canvas

Cover for novel by Brian Lumley,

Tor Books

Tor books and I have a 13-year history with Lumley's "Necroscope" series. Most of the covers have the format of a skull on the front. Horror books are very hard to do in a "narrative" way, often it is best to sum up the story with an iconic image. In this case: skulls. For this latest instalment it was suggested I show a "horrible, malformed and mutating skull". I painted it mainly with a palette knife, working very quickly. Brian Lumley liked the result so much that he bought the original.'

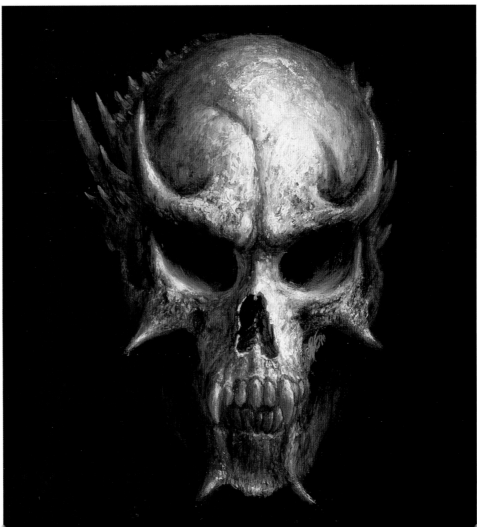

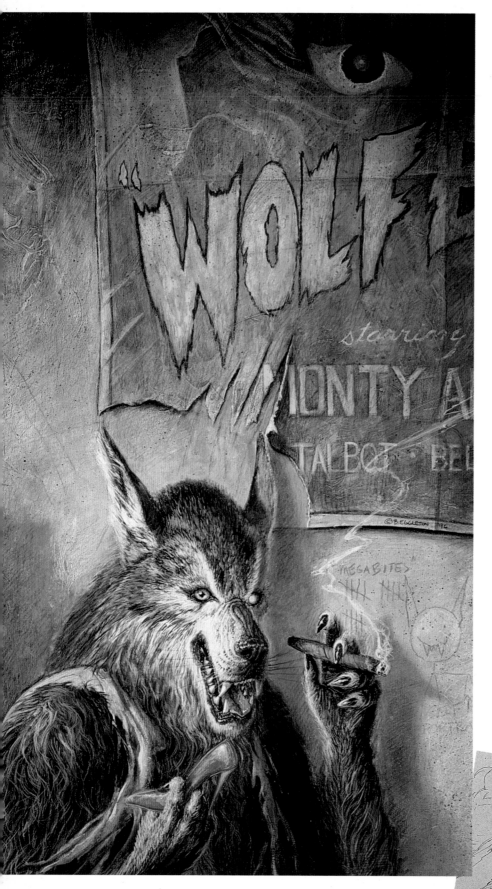

Hair of the Dog, 1997 *(left)*
38 x 33 cm (15 x 13 in)
Acrylics and coloured pencil on board
Cover for novel by Brett Davis,
Baen Books
This tale was about an alternate reality
where creatures that resemble wolves
act in movies and can transform into
wolves at will. It was generally a fun
book and a chance to exercise my
darker sense of humour. I like having
fun with this kind of subject, because
I believe horror is a genre that often
takes itself too seriously.

Castle in the Sun, 1998
(facing page)
36 x 28 cm (14 x 11 in)
Oils on canvas
Cover for *The Magazine of Fantasy
and Science Fiction*
Sometimes when you are really stuck
for an idea, the most obvious one is
the best. This was a story that had
almost no visual fantasy elements and it
dealt with a tormented 13-year-old girl.
The castle seemed to be the best way
to go. If you look carefully, you can
see the girl, small on the hillside next to
the castle. The ray of sunlight that
seems to bathe her is her ray of hope.
The publisher didn't think this would be
an "effective" cover. Well, the editor
and many others who saw it thought
differently, commenting: "There should
be more covers like that!"

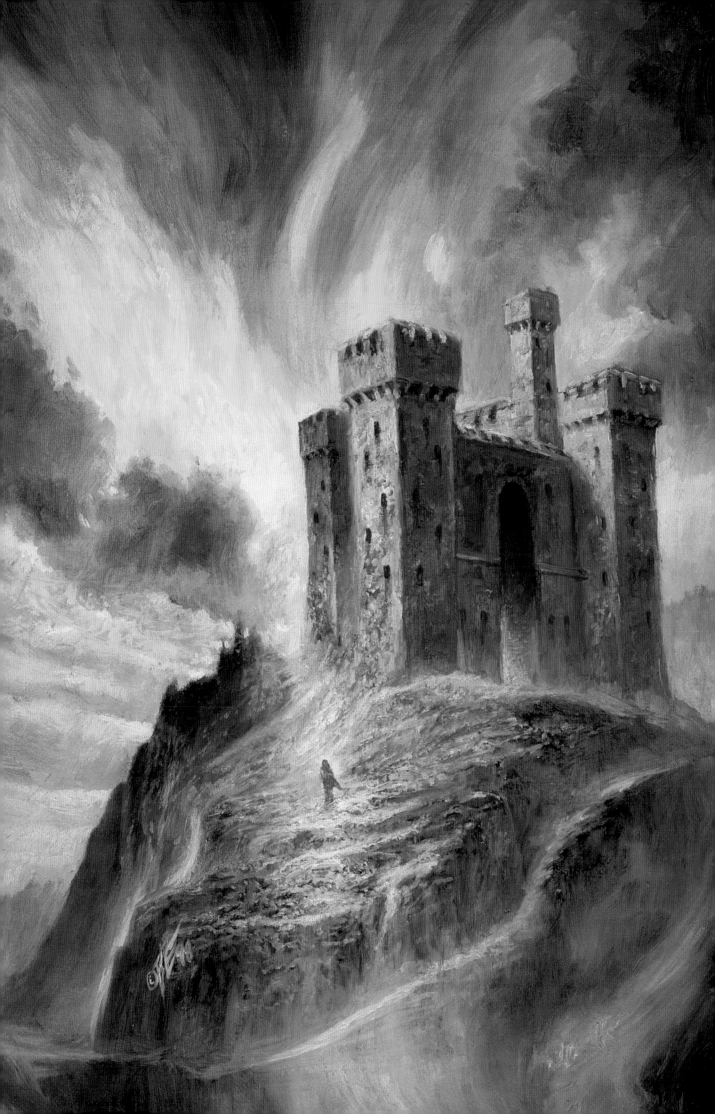

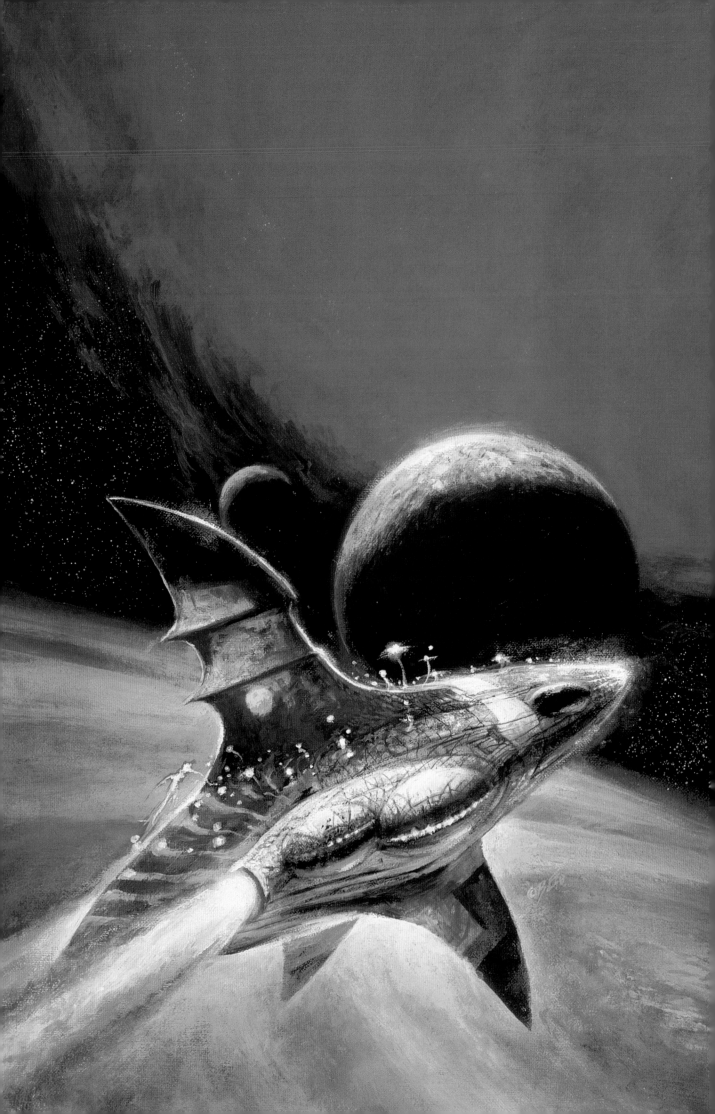

Riders to the Stars

Bob Eggleton is ambivalent about scientific advances. On the one hand, as is clear in many of his pictures, he is in love with space and the idea of space travel. On the other, he has large reservations about many of the ways technology is currently applied: "I am not afraid of progress, but I am of technology. I think technological advances have to be tempered with the humble thought that maybe we do not know as much as we think we do. Some people want desperately to go to the stars and live there. Others wish we would stay at home and fix the problems with the human race. I think we should do both. Clearly, the society of the last

Lucidity Star Drive, 1997

(facing page)

60 x 46 cm (24 x 18 in)

Acrylics on canvas

Cover for *Vacuum Diagrams* by Stephen Baxter, HarperCollins

A vision set far into the future. It had to feature a spaceship and I could not resist making the ship look like a whale, simply because that was a pleasing form to paint. The book was, in fact, a series of connected short stories.

Moons of Fire, 1995 *(right)*

50 x 36 cm (20 x 14 in)

Acrylics on canvas

Unpublished

This was commissioned for a book cover but not used. The client asked for a spaceship and "something with the Earth and the Moon on it". In the end, a less science-fictional cover was used. Still, the piece holds up pretty well. I really like organically designed spaceships and such, they are just a lot of fun to invent, and pleasing to the eye.

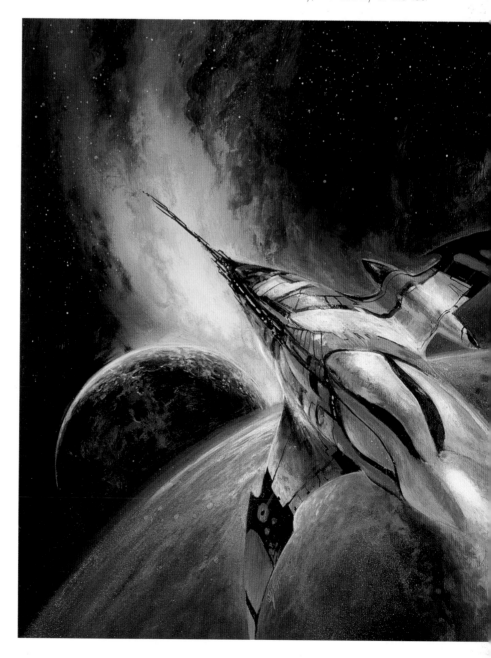

century, the 20th century, was somewhat immature. While Man has done some marvellous things, such as putting humans on the Moon, he's also done a lot of foolish things. Wars are insane. It is mankind at his worst. Man fights wars and uses technology he knows little of to do so much damage. The atomic bomb is one such device. It was "tested" over 1,800 times in the 1940s and 1950s above ground. In the end, no-one knew really why they were endlessly releasing the mushroom clouds of poisonous energy, except to show "the other side" (who were doing the same thing) that perhaps one more bomb could be exploded. Radioactive fallout still encircles the Earth today, while the cause of this repeated testing, the Cold War, is now defunct.

"I believe humans will be riders to the stars. It's a long ways off, and probably will not happen in my lifetime, but I believe we'll do it. Perhaps then, the passions of a united

Into the Comet, 1995

(facing page)
64 x 45 cm (25 x 18 in)
Gouache on board
Cover for *In the Ocean of Night* by
Gregory Benford. Gollanz (UK)
This was a lot of fun to do. I wanted
tremendous action to convey the
turbulent entry of a comet hurtling
across space, on its way to colliding
with Earth. Strangely, it looks almost
like a scene from the 1998 film
Armageddon. I used some airbrush to
create a haze around Earth, but most
of it is straightforward painting.

The Spirit of Science Fiction, 1999 *(above)*

20 x 76 cm (8 x 30 in)
Acrylics on canvas board
Private work
I have thought for a while now that
science fiction of late has lost its "gosh
wow" feel of many decades ago. I
think that as we approached the
millennium a sense of cynicism in sf
invaded the "beautiful world"
envisioned half a century ago by the
"golden age" authors of the genre.
While ruminating over this feeling, I
saw an odd-shaped board in my
studio. Every artist has lots of these
hanging about, propped against walls
and gathering dust. Well, I decided to
solve a problem: what could I do
within the confines of such an unusual
shaped piece? I started painting a
planetscape the way they were
supposed to be and upon finishing, or
so I thought, I then realized something
was missing. So I added the small
pointy-looking craft in the mid-ground
and then it was finished.

The Hole Truth, 1995 *(below)*

46 x 46 cm (18 x 18 in)
Acrylics on board
Editorial illustration for *Science Fiction
Age* Magazine
In this short story by Greg Benford we
have a ship that finds a life form at the
edge of a black hole's accretion disk.
What a truly alien environment this
would be with an equally alien
creature, a free-form shaped thing.
What wonders await us in the dark
depths of space!

human race will overrun the rusted wheels of bureaucratic governments. The main reason why, at this present time, there are no mad dashes to get to Mars, as there was to the Moon in the 1960s, is as sf author Ben Bova put it "A lack of a political driver to do so". If all of the sudden the asteroids, or Mars, were discovered to be made of solid gold, then you'd see a "political driver" start up very fast and we'd be there within a few years!

"I find the imaginary spaceships of the 1940s and 1950s to be the most interesting to look at. Many modern ships, from the 1960s onwards, seem so...sterile and just plain boring. I like organic-looking machines, spacecraft that look like they were fun to come up with."

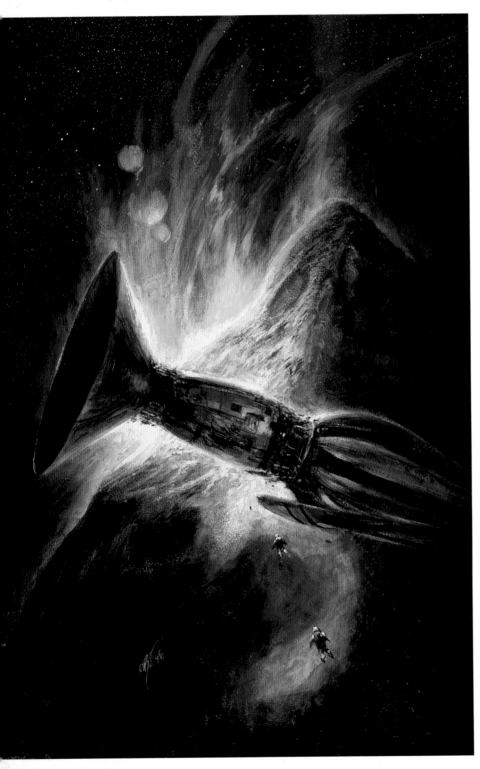

A Deepness in the Sky, 1998
(left)
38 x 28 cm (15 x 11 in)
Acrylics on watercolour board
Cover for the novel by Vernor Vinge,
Tor Books
This jacket painting was for a really big, star-spanning novel by Hugo-winner Vernor Vinge. It has some interesting alien forms in it, but because they are the Big Mystery of the book it would have been a mistake to show them. Also, I wanted a "big book" look to this novel, and the ram-jet starship to resemble the Holy Grail, symbolizing the search for the aliens. It worked out well as the author was quite happy with this. I painted this almost entirely with a palette knife, scouring on paint, scraping it all, washing it in...it was very loose and painterly. But then, the painting has been compared to "Turner if he did sf". I guess you can't get a better vote of confidence.

A Cave of Stars, 1999
(facing page)
60 x 46 cm (24 x 18 in)
Acrylics on canvas
Cover for the novel by George Zebrowski, HarperCollins
George and I are good friends. He always requests I do his covers when he can. The best thing about a Zebrowski book is the visual feast it is. He writes "big" and grand sf novels that deal with humans travelling around space and contacting other life forms. George has many tales to tell yet. I hope he does for a long, long time.

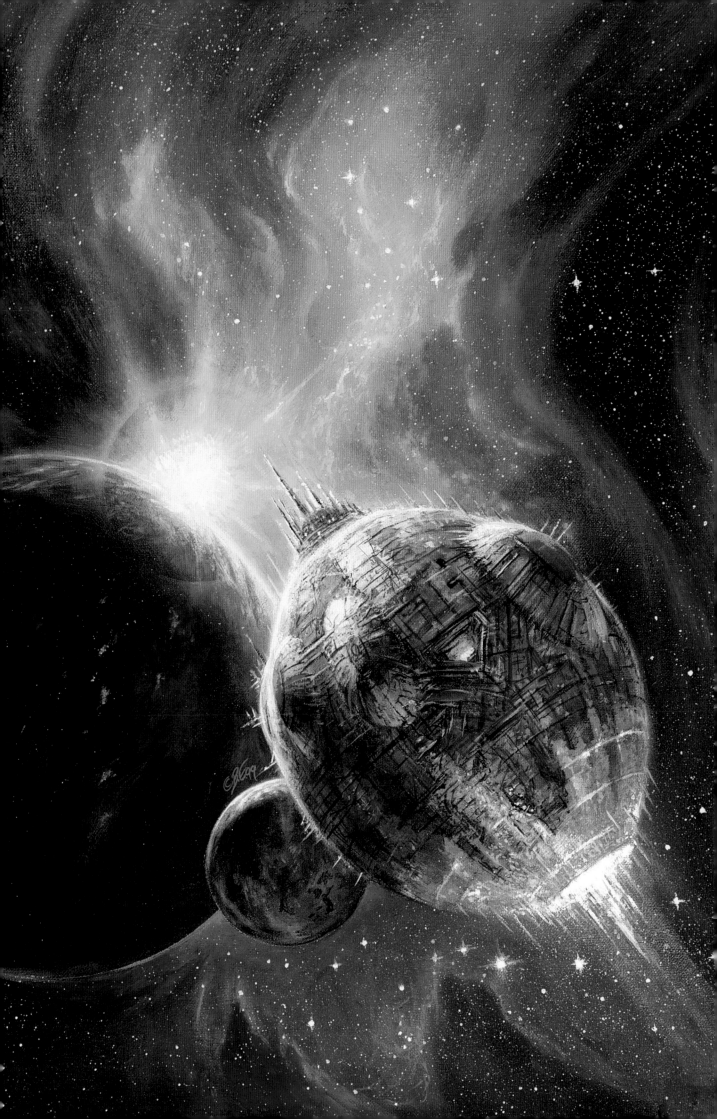

Pirates of the Universe, 1995
30 x 70 cm (12 x 27 in)
Acrylics on board
Cover for the novel by Terry Bisson,
Tor Books
The strange aliens are the oval-shaped, brightly coloured life forms. Again, the publisher asked for a spaceship to convey the true science-fictional aspect of the book to the potential readers. In the end, a design company took the painting and cut it up digitally and redesigned it with the appropriate type. So this is the first time the painting has been reproduced the way it was originally conceived and painted.

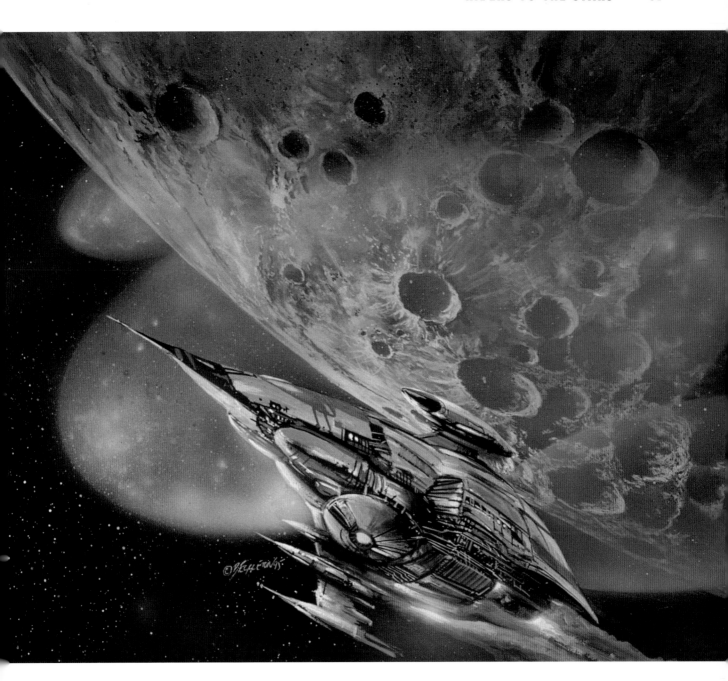

Bob has always followed the American space programme with great interest, but also growing disappointment as the energy has drained out of it: "The dreams are still there, but they're just not getting through. Looking back to the golden days of the 1960s, it was a different set-up entirely. They let ingenuity take over and went for it in a kind of heady rush. The safety factor was nothing compared to today, they just flew by the seat of their pants. I find it almost unbelievable now that we ever got to the Moon back in 1969."

Bob's own guess is that private enterprise will take over in the next leap towards the stars. Already there is serious talk in Las Vegas of building a casino on the Moon. Would he book a ticket, assuming some rich gambler had just bought a painting from him for enough money?: "Well, it might sound funny, but I would if the toilets worked properly. It's an interesting concept, but I'm really not into claustrophobia." So he'd go if they offered proper toilets and a real spaceship you could move around in, but not at any cost?: "Absolutely."

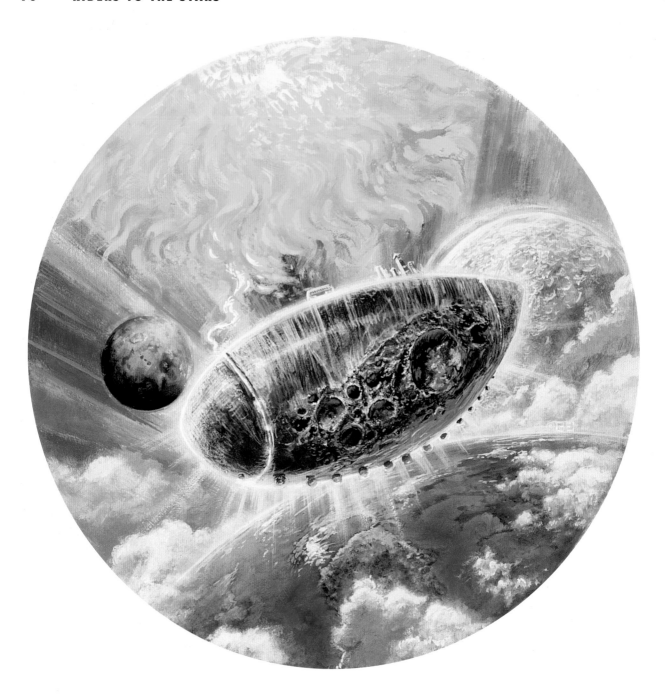

Celestial Matters, 1995 *(above)*
36 cm (14 in) diameter
Acrylics on board
Cover for the novel by Richard
Garfinkle, Tor Books
This is a really wild "alternate reality" sf
book in which the science of ancient
Greece is, in fact, the way things
actually work. So the sun orbits the
Earth, etc. In this Ptolemaic universe we
see the ship "Chandra's Tear" made
from a piece of the Moon. I wanted to
paint this like an old fresco, complete
with that type of brushstroke.

Ring, 1995 *(right)*
66 x 33 cm (26 x 13 in)
Acrylics on board
Cover for the novel by Stephen Baxter,
HarperCollins
In Baxter's far future scenario, the
Earth's solar system has greatly
changed. The sun has entered a giant
red stage and Jupiter has basically

flattened out to become a strange
environment with even stranger life
forms. The ship was described as
being very organic and attached to a
chunk of ice or rock at the end. I often
find with some sf novels, that for high
impact, simplicity is the better part of
valour, which is why I tried to make this
really clean and simple.

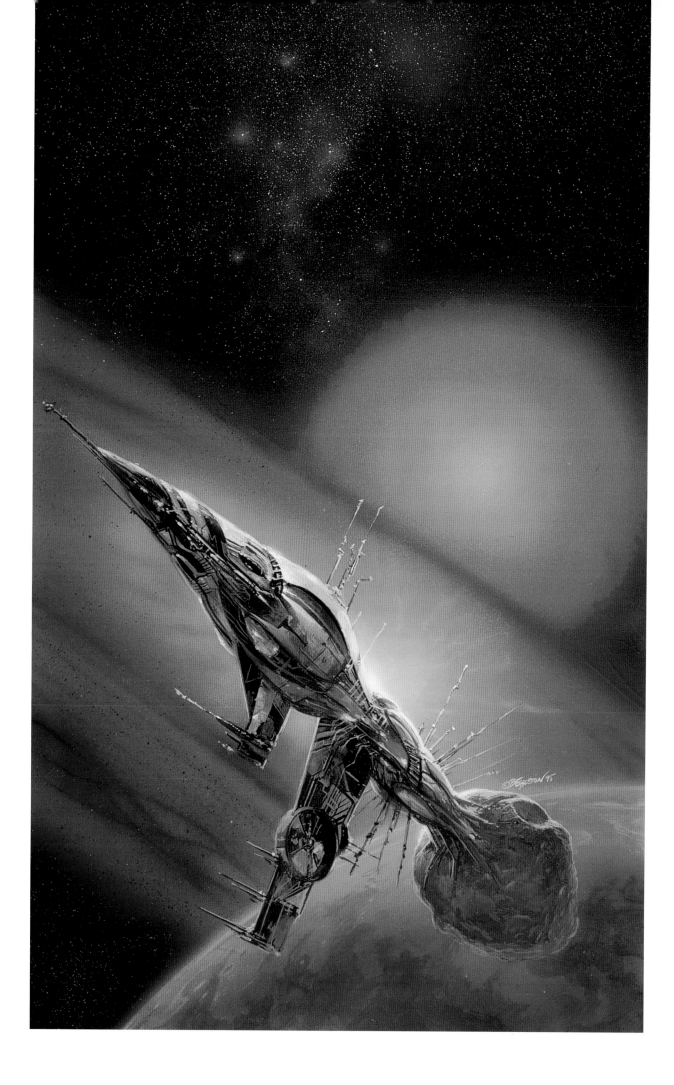

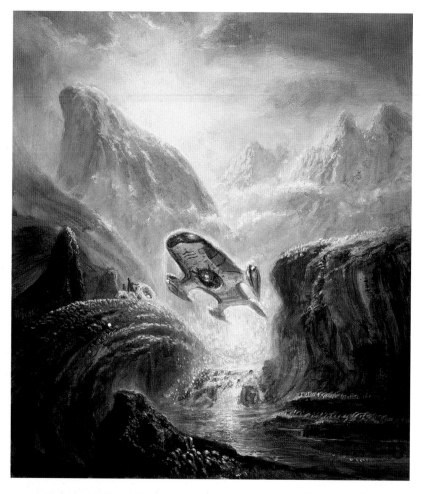

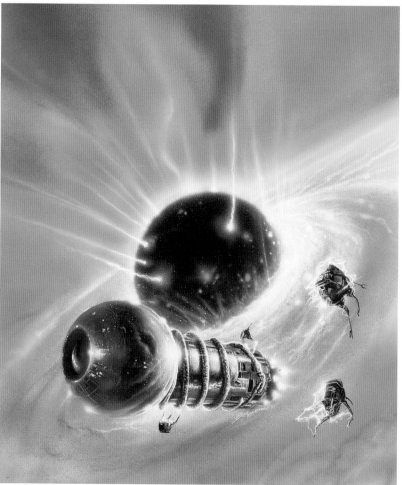

The Children Star, 1998 *(left)*
46 x 33 cm (18 x 13 in)
Acrylics on board
Cover for the novel by Joan Sloncewicz, Tor Books
The story of a truly alien planet, one so hostile that humans must be physically altered in order to live there. I wanted a "Turner-esque" feel to this painting, together with a depiction of a very alien environment.

Gravity Well, 1995 *(below left)*
46 x 33 cm (18 x 13 in)
Acrylics on board
Editorial illustration, *Analog* Magazine
Greg Benford is a master of "Hard" sf and this short story was no exception. In it, a neutron star has become trapped on the surface of the sun. Its gravity is so powerful that it generates a huge field of strange effects. Our astronaut, in the lightbulb-shaped craft, has to inspect this strange event. I liked the chance to do a painting that is "space" oriented, but doesn't have much of a black background.

A Matter of Time, 1998
(facing page)
50 x 40 cm (20 x 16 in)
Acrylics on canvas
Cover for *The Magazine of Fantasy and Science Fiction*, May 1998
Chesley Award-winner 1999 for Best Magazine Cover
This was for a terrific sf short story about a ship from Earth which returns home after many hundreds of years. During that time, aliens have invaded and destroyed most of the evidence of Man's existence, putting up their own structures. In time, the aliens either died or left, leaving their own buildings to the elements. Here, the Earth ship is landing and we see signs of some overgrown, destroyed alien structure that is still partly standing in an otherwise pastoral landscape.

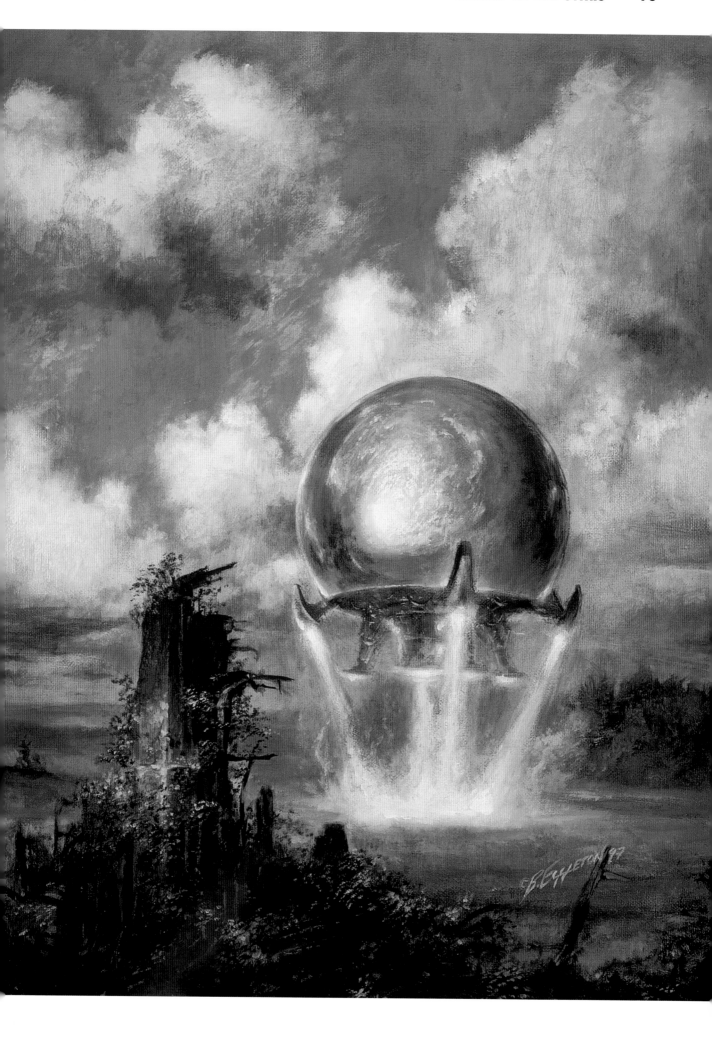

Saturn Ruhk, 1996 *(right)*
46 x 66 cm (18 x 26 in)
Acrylics on board
Cover for the novel by Robert
Forward, Tor Books
Saturn, like Jupiter and the other
gaseous planets, has no visible
surface. Any solid surface would lie
under miles of clouds and roiling gas,
and be subject to pressures that would
flatten a dinosaur, so any life forms
that developed would have to evolve
in a freefall environment. This is one
such life form suggested in the story,
a species with a wingspan of literally
miles. Landing on one would be like
landing on a floating platform. I
wanted the creatures to look sort of
like big colourful manta rays, which is
basically how Forward describes them.

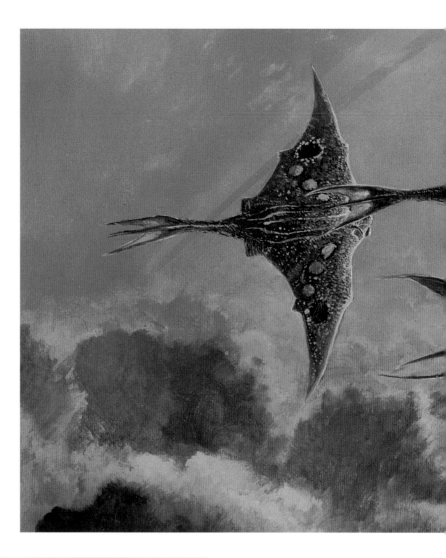

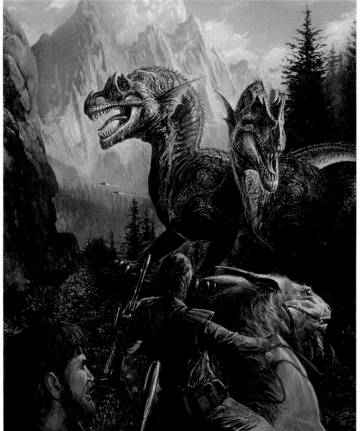

Dragons of Genellan, 1995 *(left)*
64 x 36 cm (25 x 14 in)
Acrylics on watercolour board
Cover for *Genellan II* by Scott Gier,
Ballantine Del Rey Books
This was the second of a trilogy that I
illustrated for this new author. I found
the books highly entertaining with lots
of colourful alien surroundings, and
eclectic alien beings! In this scene,
the colonists have come across an
indigenous life form that resembles a
dinosaur, a Genellan Dragon. I wanted
to evoke a "what happens next?" sort
of feeling. Do they escape? You'll have
to read the novel and find out. The
author liked my three paintings so much
that he bought them all!

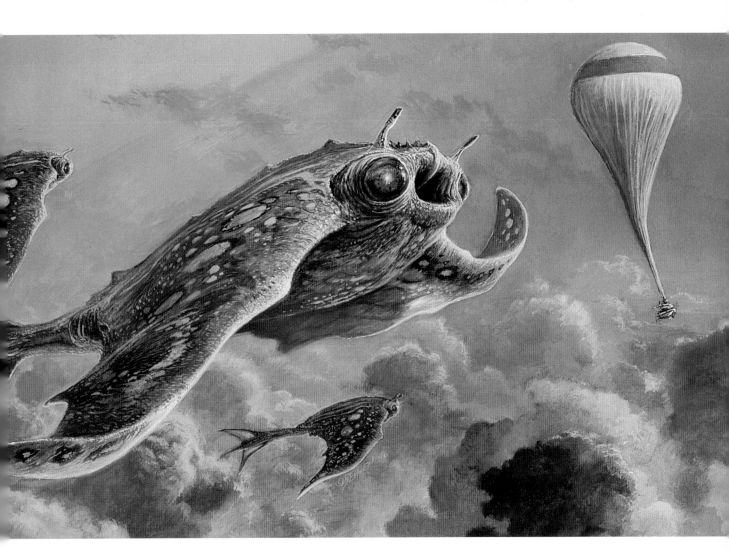

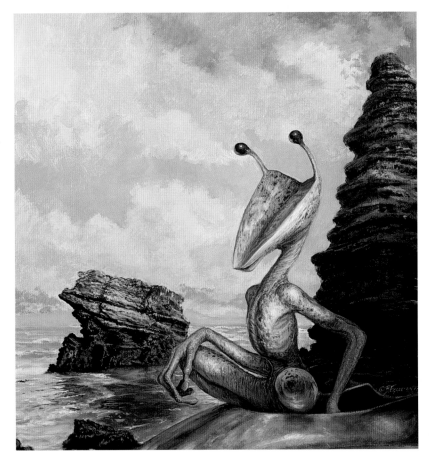

O Pioneer, 1997 *(left)*
38 x 33 cm (15 x 13 in)
Acrylics on board
Cover for *Analog* magazine
For a serialized story by sf
grandmaster Fredrik Pohl about the
colonization of yet another world! It's
a colourful, fun story involving
teleportation as a means of getting to
another planet. This interesting creature
is the pilot of a craft. The alien-looking
rock formations in the background are
actually based on some interesting
rocks I found on the Victoria coastline
while exploring Australia. I
photographed them, knowing that one
day I would use them, but I didn't
realize it would be so soon when I
found this story was waiting for me on
my return home.

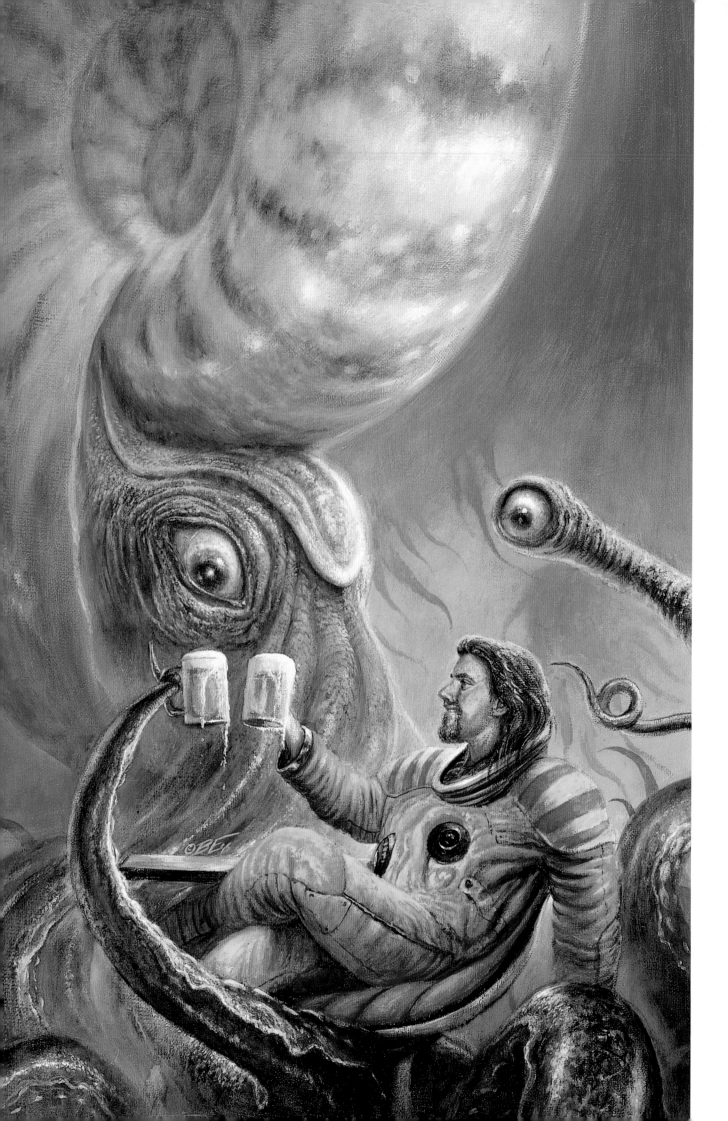

There are More Things in Heaven and Earth

When Bob paints aliens, he is usually not trying to suggest that this is seriously what they will be like, if and when we ever meet any. He just has fun with the interesting forms that are allowed, playing with the idea of appearance and our perception of character. His aliens are usually anthropomorphic to give viewers something to identify with. Basing them on animals also conjures up character. As with spaceships, Bob goes for pleasing shapes more than "authenticity".

Ideally, for him, the alien should not be over-described in the story he's illustrating because this leaves more scope for imagination. He finds that most writers don't have a clear picture in their head of their aliens, even when they have described them in minute detail. Often it is only when the right artist comes along that they see their own creations clearly. To a visual artist this may seem odd, but everyone's imagination works differently.

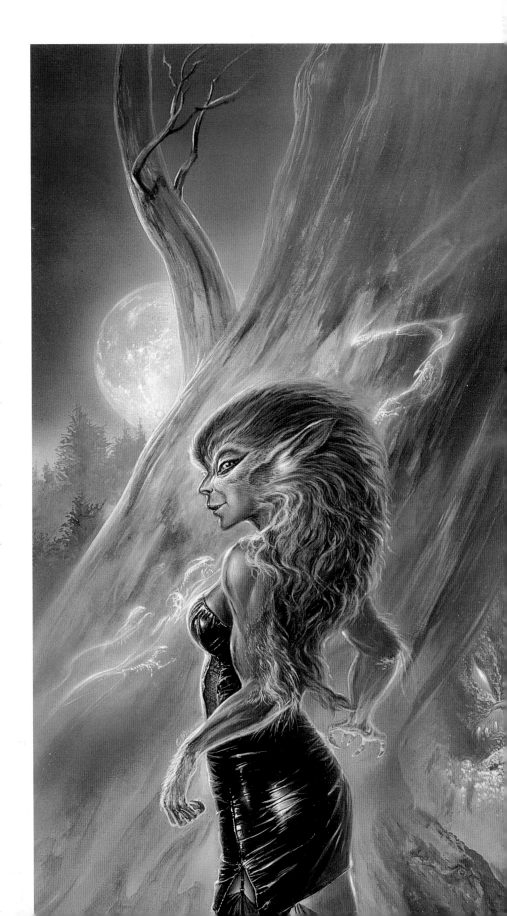

A Pint with a Mollusc, 1999
(page 76)
30 x 20 cm (12 x 8 in)
Acrylics on canvas
Cover for *Forge of the Elders* by
L. Neil Smith, Baen Books
This is a great book. Humorous in
places, it comes off like a Lovecraft-
inspired novel. I wanted very garish
colours and the feel of a 1940s pulp
cover. Plus, I could not resist putting
myself in the lead human character
role, since I am a cheap and
available model. What better way is
there when we first make alien contact
than to meet over a pint of lager?

Man-a-cure, 1995 (page 77)
70 x 46 cm (28 x 18 in)
Acrylics on board
Cover illustration for *One Foot in the
Grave* by Wm. Mark Simmons,
Baen Books
This was a blast to do, though it shows
a little bit more about me than maybe I
should want people to know! The
assignment was tough. The book was
basically a horror story, but with some
humour. The publisher didn't want it to
appear that way. He wanted a
fantasy feel. Well, I went off on a
tangent. I created a sexy half-human,
half-wolf thing in a black leather
miniskirt. I was also more than a little
inspired by some Japanese Anime
films, which I really like.

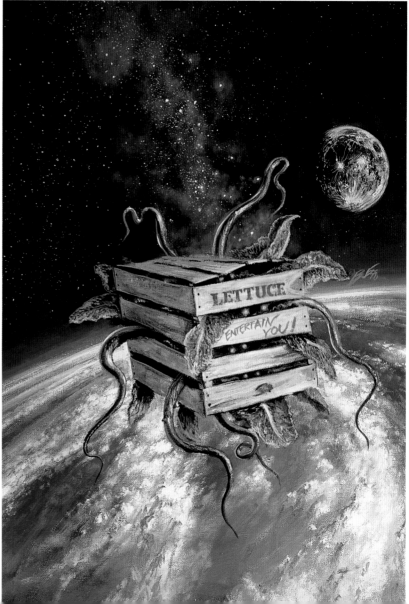

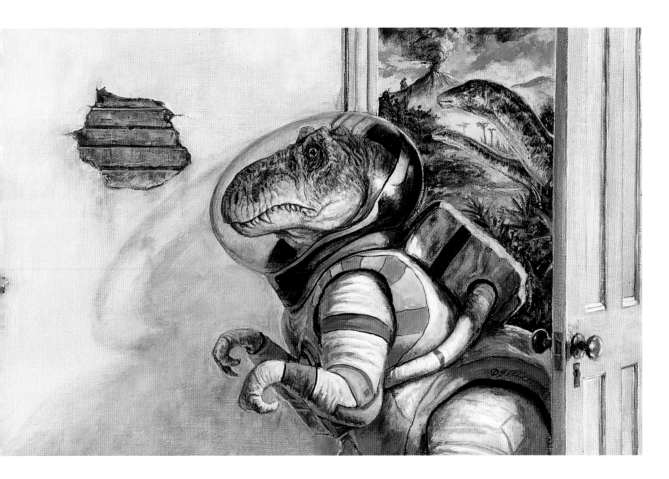

Lettuce Entertain You, 1998

(facing page)
36 x 30 cm (14 x 12 in)
Acrylics on canvas
Anthology cover, Baen Books
Anthologies are almost always fun
jobs. Publisher Jim Baen wanted a
cover to a book entitled *Dangerous
Vegetables*. I couldn't resist. So Jim
thought up the basic idea and it had to
include "Lettuce Entertain You" on the
lettuce crate. I had thought of "Lettuce
Romain In Orbit" but that would have
had me shot by pun hunters. It was so
pleasing to do such a humorous cover,
after a series of intense and grinding
ones...we all need a sense of humour
otherwise we'll end up without a soul.

Think Like a Dinosaur, 1997

(above)
30 x 48 cm (12 x 19 in)
Acrylics on canvas
Cover for short story collection by
James Patrick Kelly, Golden Gryphon
Press/Publishers
The author had always wanted an
image of a dinosaur in a spacesuit
against a Rousseau-like jungle
background. I went with this idea, and

then I saw some paintings by Rene
Magritte and thought I would have fun
with that influence. What I ended up
with was this little dinosaur escaping
the age of dinosaurs to the future.
Which had nothing to do with the
actual story "Think Like A Dinosaur" –
it's just the author, publisher Jim Turner
and myself all wanting to have a little
fun and do something that would
completely throw everyone off!

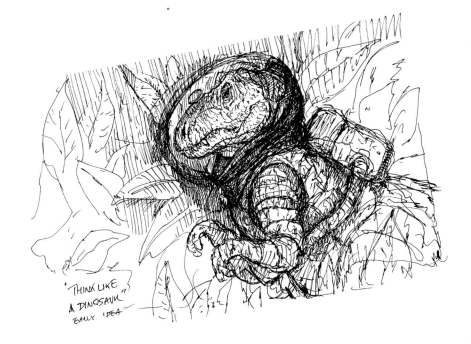

"THINK LIKE"
A DINOSAUR
EARLY IDEA

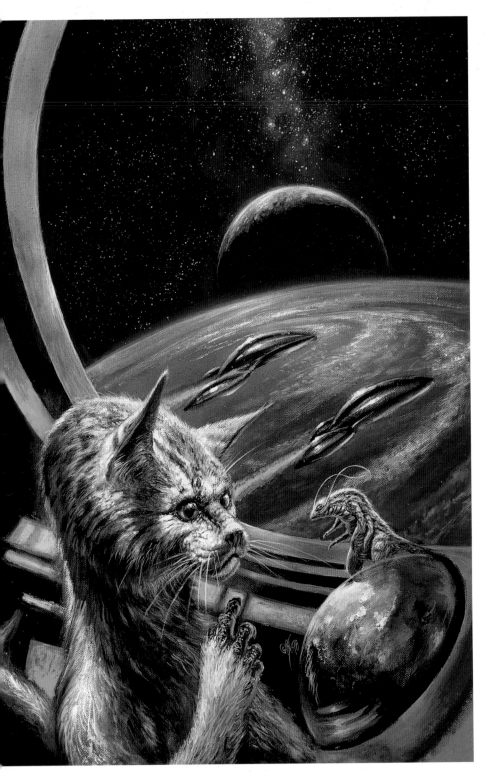

Skitty, 1998 *(left)*
48 x 28 cm (19 x 11 in)
Acrylics on canvas
Cover for the novel *Werehunter* by
Mercedes Lackey, Baen Books
This interesting creature is a
intelligence-modified cat. Well, I think
cats are highly intelligent anyhow, as
the most incredible thing cats have
done is convince people they are
dumb. In this scene, we see the cat
looking at what would be the
equivalent of an alien mouse.

Kzindependence Day, 1995
(facing page)
72 x 36 cm (28 x 14 in)
Acrylics on board
Cover for *A Darker Geometry* by
Gregory Benford and Mark O. Martin,
based on Larry Niven's Man-Kzin
Wars series
In Niven's universe, these are Kzin,
fierce warriors who like nothing better
than to fight like tigers, but they also
have the temperaments of household
cats when at rest. This was pure joy to
do, the creatures' hair texture was fun
to paint and coming up with a
dramatic composition was a challenge.

Bob plainly has a vivid imagination, but he does not believe it to be a special gift.
When he was a child and people remarked on his artistic talent, he believed that
maybe it was something special. Now he thinks "talent" is an overused word, it is
actually more a case of heightened perception. "I think people are born with a
'talent' for many things, but their heads just get so cluttered up with day-to-day stuff
that they lose this. I feel it myself when I get bogged down with paying bills and so
forth. Your perceptions get dulled. You can just feel the creative energy being
sapped out of your work. But I've got to the point now of being able to turn it on
and off. If you work at anything long enough this will come. I think talent in the end
is a case of sharpening your natural perceptions all the time and sticking to them."

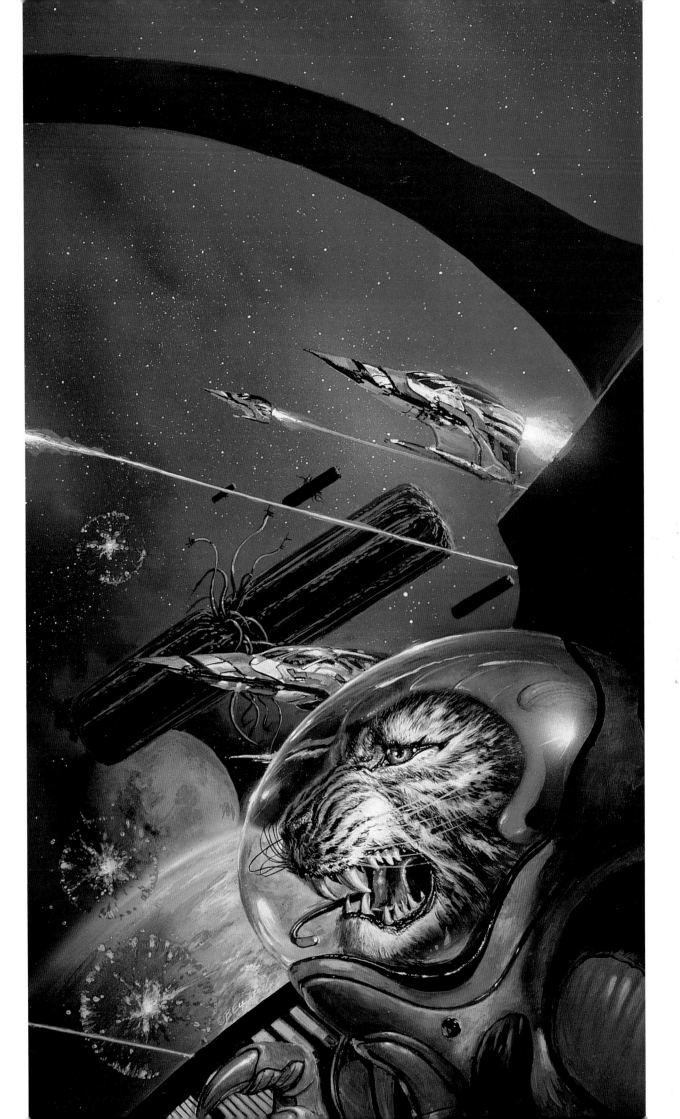

**Funeral March of the
Marionettes, 1997**

(facing page)

50 x 38 cm (20 x 15 in)

Acrylics on board

Cover for *The Magazine of Fantasy
and Science Fiction*

For a terrific Hugo-nominated story by
author Adam-Troy Castro. Just about
every character in the story was an
alien! The ball-like, tentacled thing you
see is a creature whose species move
in such large numbers, they can
blacken a horizon when on the move.
I loved the story and apparently so did
many other people. It wasn't hard
finding a fun scene to do.

The Howling Stones, 1996

(above)

72 x 66 cm (28 x 26 in)

Acrylics on board

Cover for the novel by Alan Dean
Foster, Del Rey Books

Chesley Award Winner for Best
Hardback Book 1998

Yet another of Alan Dean Foster's
strange alien worlds. This one, an
ocean-like world, has a race that holds
the key to travel through the
universe. This painting was
a "collage" composition
which, on the whole, I am
not very adept at doing,
simply because I feel they
never work right. The
alien and his skin
texture were lots of fun
to paint, as was the
island background.

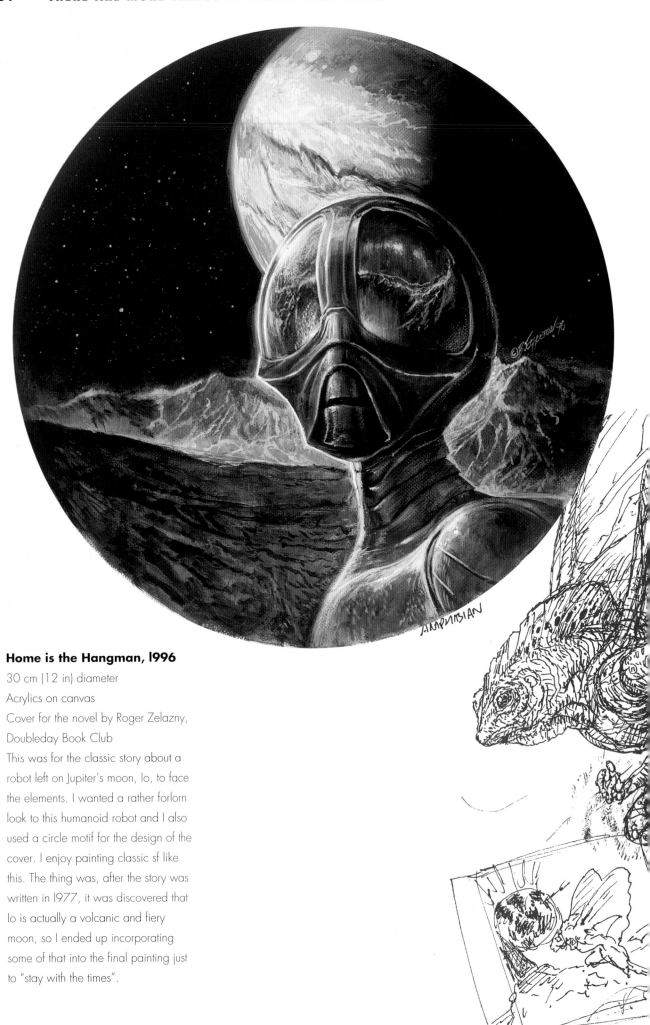

Home is the Hangman, 1996

30 cm (12 in) diameter
Acrylics on canvas
Cover for the novel by Roger Zelazny,
Doubleday Book Club
This was for the classic story about a
robot left on Jupiter's moon, Io, to face
the elements. I wanted a rather forlorn
look to this humanoid robot and I also
used a circle motif for the design of the
cover. I enjoy painting classic sf like
this. The thing was, after the story was
written in 1977, it was discovered that
Io is actually a volcanic and fiery
moon, so I ended up incorporating
some of that into the final painting just
to "stay with the times".

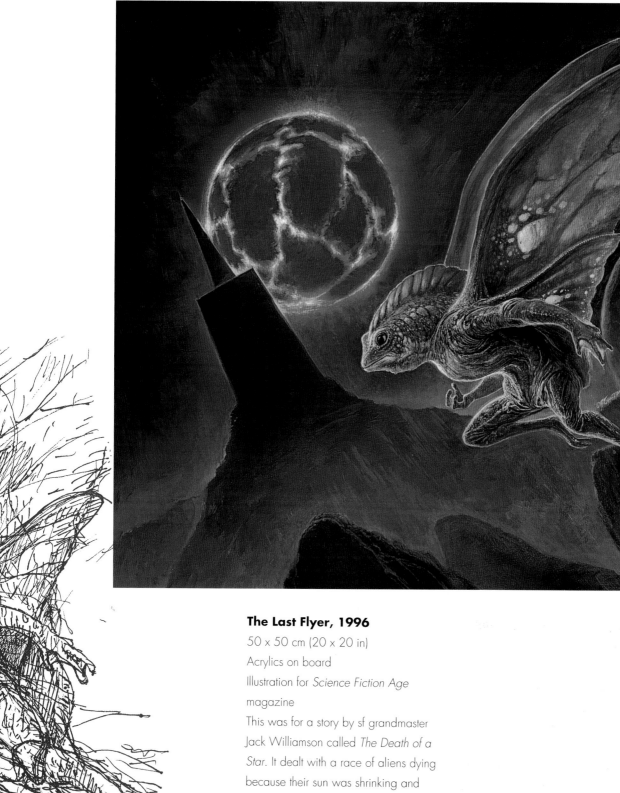

The Last Flyer, 1996

50 x 50 cm (20 x 20 in)

Acrylics on board

Illustration for *Science Fiction Age*
magazine

This was for a story by sf grandmaster
Jack Williamson called *The Death of a
Star*. It dealt with a race of aliens dying
because their sun was shrinking and
turning black. This rather amphibious
creature was peaceful in nature. His
last act was to fly to the highest spot on
his planet – a fortress – to find others
like him. It was rather a wistful story,
one I will always remember. I also
really enjoyed doing all the texture on
the creature.

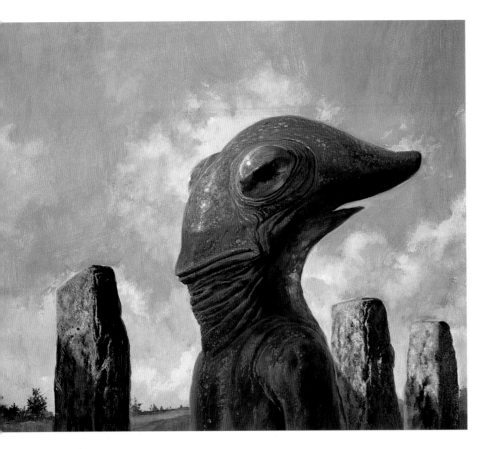

The Alien Years, 1997 *(left)*
36 x 38 cm (14 x 15 in)
Acrylics on board
Science Fiction Age magazine.
Robert Silverberg wrote a short story
about aliens that basically come to
Earth and take over. One of the things
they do is re-arrange Stonehenge's
megaliths. They are tall, limber
creatures with purplish skin. I just
made up the rest because I found an
interesting shape in the heads of
these things.

Receive the Gift, 1997
(facing page)
64 x 36 cm (25 x 14 in)
Acrylics on board
Cover for novel by Louise Marley,
Ace Books
This is an alien planet that has cycles
of intense cold and then rather nice
springtime. It has two moons and
horse-like creatures called Hruss
(pictured). The publisher wanted no
humans at all, just a pastoral planet
with only a hint of human habitation
instead. Which, as I like landscape art
so much, made it a perfect piece for
me to do!

Bob believes most people are born with the potential to be artists but that normal education is almost designed to suppress it: "When you look at children, it's evident that most of them have a lot of visual imagination, but it is often suppressed by unimaginative adults. They are told imagination is not 'practical' and so it gets stunted instead of encouraged."

Luckily his imagination was greatly encouraged at home when he was a child. Both parents supported his vision from the age of about six of being an artist when he grew up. As he approached the end of high school, there was some concern about the way ahead, though. They all visited some art colleges but were not impressed by what went on there. As they were leaving one, his father shook his head and said: "Even if their brains were dynamite, they wouldn't have to worry about explosions."

Bob was given the option of going to art college if he really wanted to, but it was a great relief all around when he decided to find his own way into the art world. And it was better still when this was vindicated by success. His father was so happy for Bob that he used to brag about it jokingly with friends who had spent a fortune putting their own kids through college, only to have them choose to go and work in a car wash afterwards.

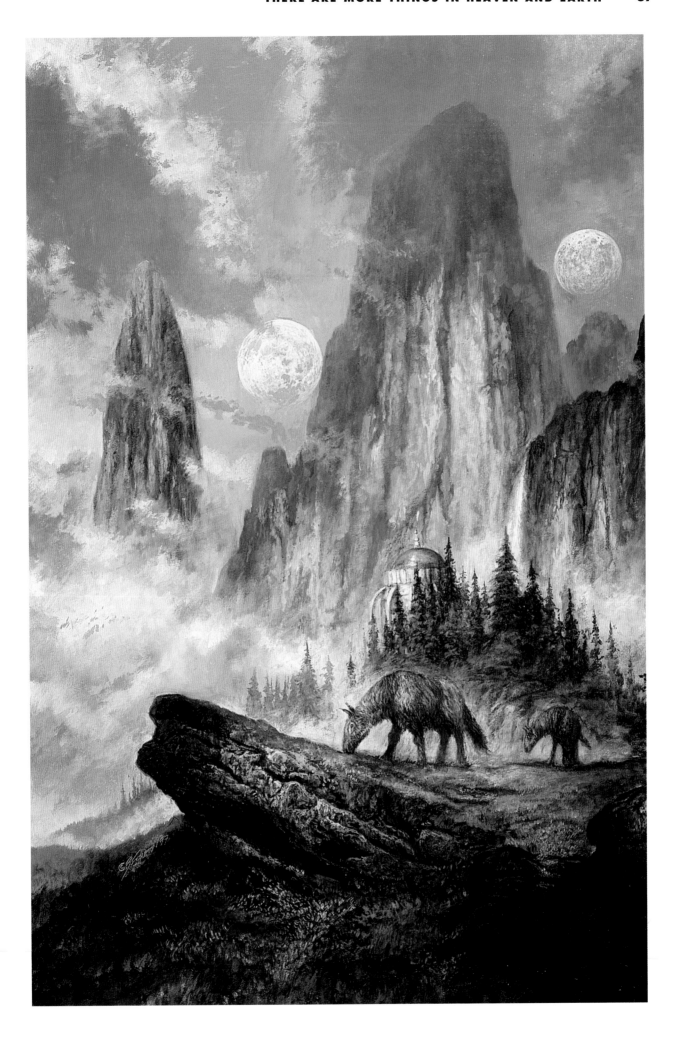

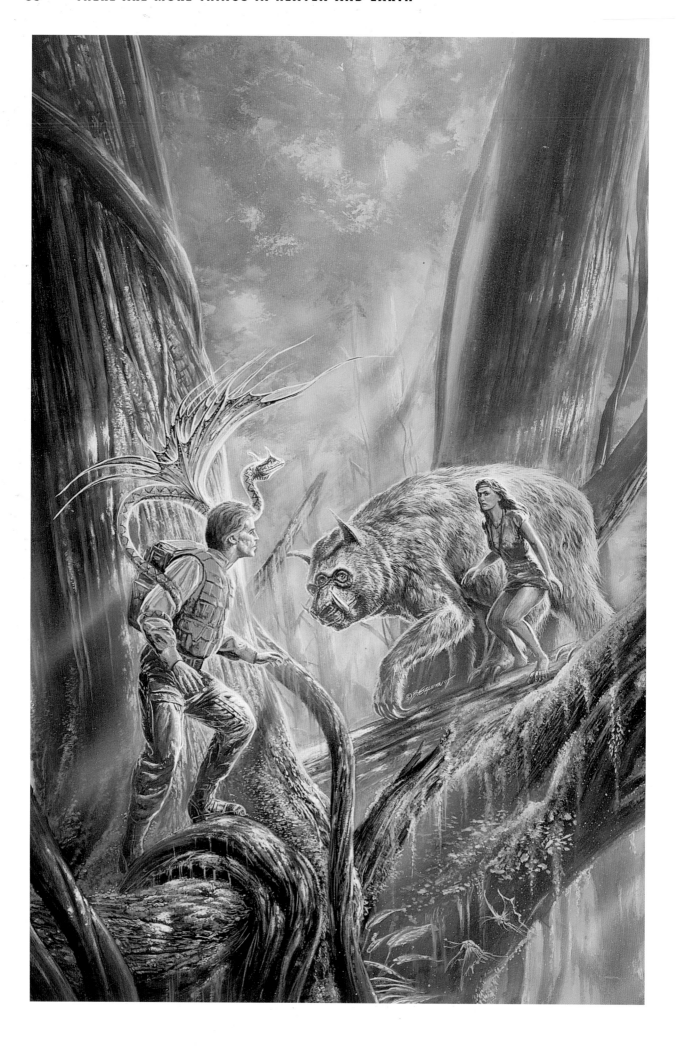

Flinx in Flux, 1995 *(right)*

50 x 30 cm (20 x 12 in)

Acrylics on board

Cover for the novel by Alan Dean
Foster, Del Rey Books

Flinx is a young boy with a penchant
for adventures and meeting weird
aliens. The snake-like creature on his
shoulder is his friend Pip, a dragon-like
species of high intelligence. In this
story he meets some rather furry, nosy
aliens in a dank cave. The problem
was how to light it. So I figured the
light would look good emanating from
insects in the cave. A lot of this piece
was done before I seriously scaled
back on using an airbrush.

Mid Flinx, 1995 *(facing page)*

60 x 45 cm (24 x 18 in)

Acrylics on board

Cover for the novel by Alan Dean
Foster, Del Rey Books

One of the newer adventures of Pip
and Flinx on the author's other world
that he created for the book *Midworld*,
a planet of dense and very high trees.
The bear-like creature with three eyes
and the girl with long fingers and
toes are natural inhabitants of this
rather green world.

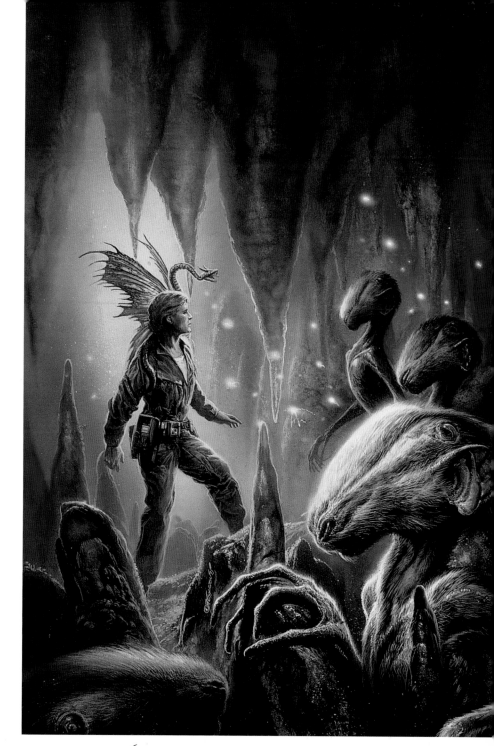

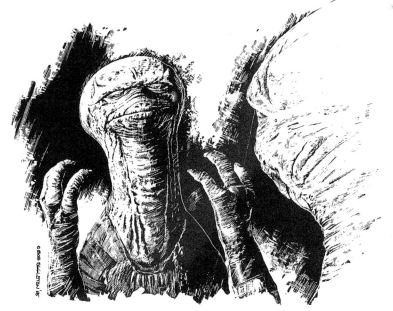

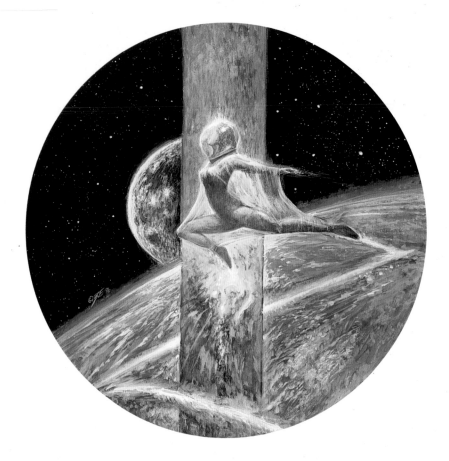

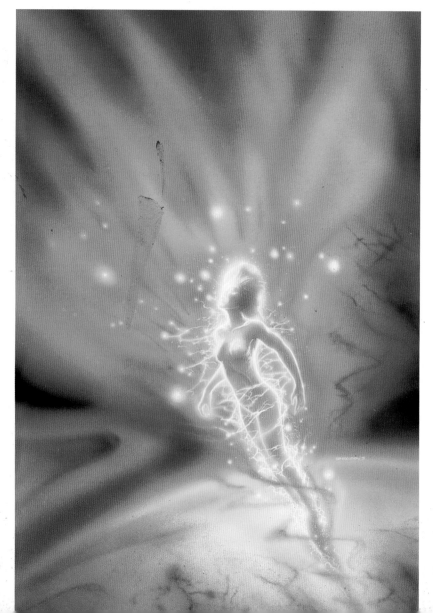

Star Dance, 1996 *(left)*
30 cm (12 in) diameter
Acrylics on board
Cover for the novel by Spider and
Jeanne Robinson, Doubleday Book Club
In this classic story, humans are able to
perform ballet in space with the aid of
special suits. Here, I used paint with an
impasto effect, to make it look like an
older painting. The story has been so
well illustrated before that it's hard to
do anything original, so a different
technical approach seemed best.

The Little Girl Who Lives On the Neutron Star, 1995 *(below left)*
43 x 30 cm (17 x 12 in)
Acrylics on board
Cover for *Flux* by Stephen Baxter,
HarperCollins
I always expect something wild from
the British sf author Stephen Baxter and
this was no exception. It's a story about
genetically engineered, microscopic
humans who live in the intense
gravitational environment of a neutron
star. On this star exist little English
villages made of star matter. This piece
is about 99 per cent airbrushed
because it was so ethereal. It also had
to be a simple, high impact cover to
please the publisher.

Airborne, 1996 *(facing page)*
66 x 50 cm (26 x 20 in)
Acrylics on board
Cover for *The Magazine of Fantasy
and Science Fiction*
Sometimes the fantastical element in
stories is hard to depict as it is only
talked about vaguely. This was such a
story, by Nina Kiriki Hoffman. I ended
up depicting the girl, levitating and sort
of eclipsing a graveyard statue with
stone wings. Not many people get that
point until a second look. The painting
is also a benchmark piece in my
career. I was very happy to get a
Chesley Award for this piece in 1998.

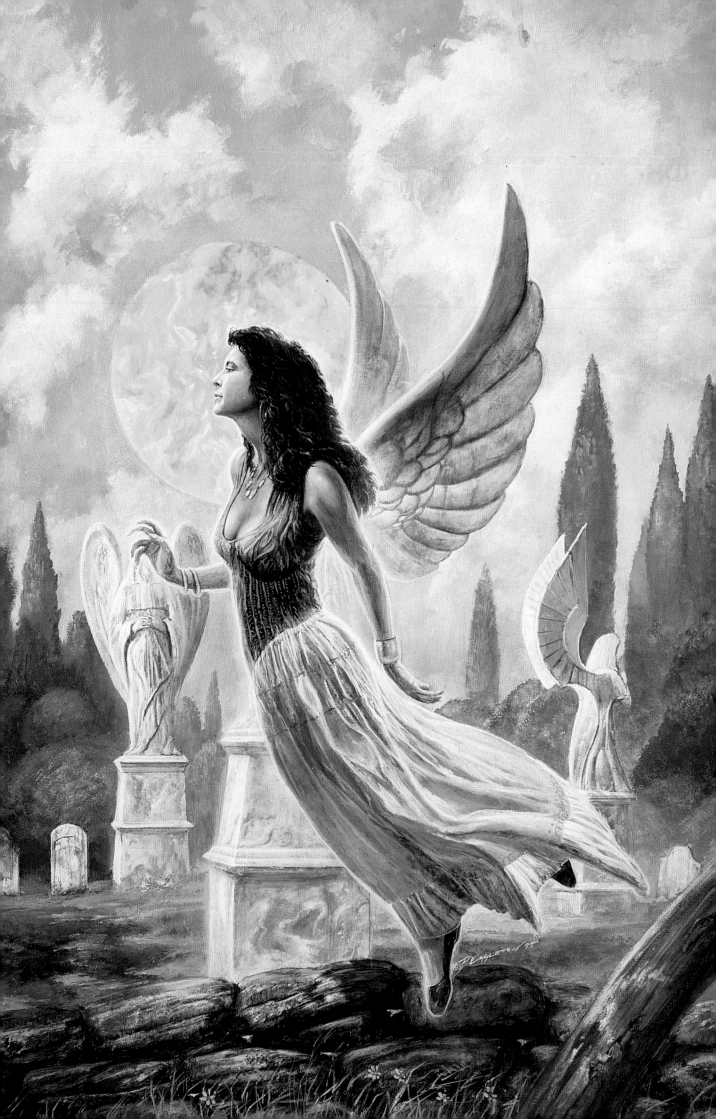

THRILL RIDES AND EVENT HORIZONS

*I*n 1996, quite out of the blue, Bob received a call from a director called Mario Kamberg who was working with the Oscar-winning visual effects studio, Rhythm & Hues. They engaged him as a visual consultant for a new Las Vegas thrill ride to be called "Star Trek: The Experience". Bob: "I found working with Mario to be highly stimulating, and I thank him for pushing my creative edge beyond its limits. It resulted in me doing even more creative things in other aspects of my career!"

He was asked to come up with ideas for two segments of a four-and-a-half minute visual effects sequence that would eventually be programmed into a flight simulator motion base to create the illusion of flying through space. The scenario called for a flight through the rings of an alien planet and a view of the planet itself from space. He was also asked to contribute ideas for the "wormhole" sequence toward the end of the ride.

The ringed world he came up with had to be unlike anything designed before. Instead of ice particles, which are what most planetary rings are made from, including Saturn's, he opted for the offbeat idea that these rings could be fluid-looking and, in fact, made of strange gases. Kamberg liked the idea a lot and managed to incorporate it into the film. When Bob finally got to

Beyond the Farthest Star

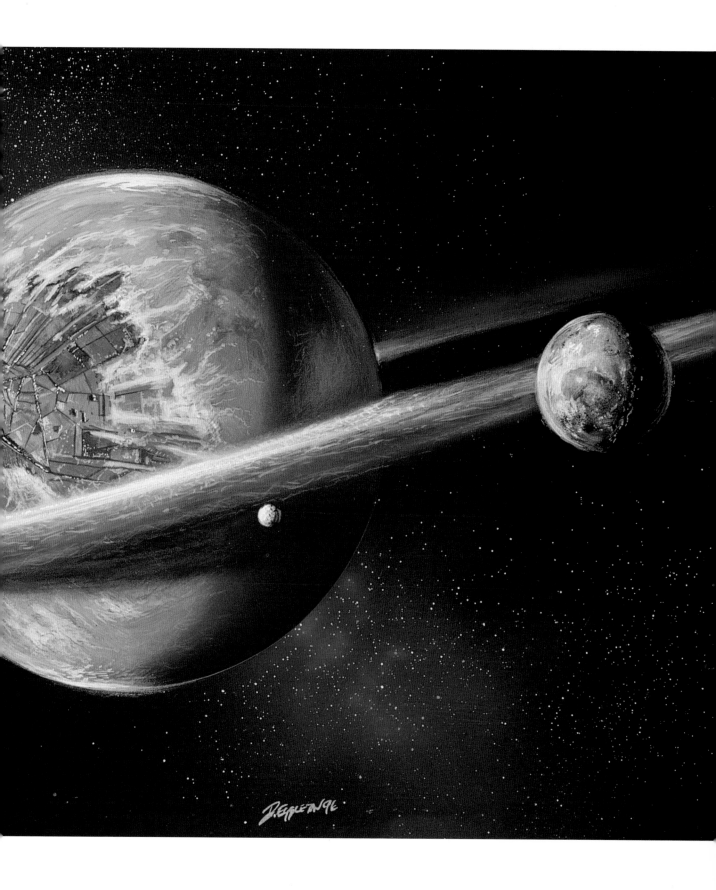

UNDULATING "WALLS" STATIC CHARGES →

VORTE

Ringed World, 1996

(previous pages)
40 x 50 cm (15 x 20 in)
Acrylics on board
Concept design
This was to illustrate the concept of an alien world with gas rings. It was eventually rendered via CGI (Computer Graphic Imaging). A tight concept was needed as a "blueprint" for animators to render texture, colour etc.

experience the ride for himself, the sensation of flying through one of his own paintings, that had been computer-animated and turned into stunning three dimensions, was: "just sheer mindblowing".

Also shown here are some of his ideas for the final "wormhole" sequence. One was of a "crystalline" interior forming out of the rather nebulous bulk of the wormhole (*see* page 96). They also explored (see sketches) the possibility of making the wormhole seem organic, almost like exploring a human or animal body; and, going to the other extreme, nebulous and very gaseous. Because the sequence was somewhat trimmed, most of these concepts were unused and the end result in the film is much simpler, but in Bob's opinion it still looks pretty good! Visitors to Las Vegas can check it out for themselves.

Undulating Walls, 1996 *(left)*
7 x 15 cm (3 x 6 in)
Pastel and coloured pencil on
black paper
Concept sketch

**Organic Tendrils, Electrical
Charges, 1996** *(below)*
7 x 15 cm (3 x 6 in)
Pastel and coloured pencil on
black paper
Concept sketch to explore wormhole
textures and shapes.

Bob really enjoys painting straight spacescapes and often turns to them for relaxation and pure pleasure when feeling jaded by other themes. "I'm not too much into the mathematics of it though. Some artists analyze and analyze a scene to the point of talking themselves out of doing anything at all. Or else it comes out so diagrammatic there's no life or feeling in it. Spacescapes are no different from landscapes, apart from being set on other planets. All the usual rules apply. And what is most important is that the drama comes before strict accuracy. The scene must feel convincing, but you have to trust the art to take care of itself. You have to go along with it as a painting first of all."

Many of his spacescapes have been published in scientific magazines. Does he ever get panned by the experts? "Oh yes, occasionally. My answer is to tell them to go to the planet and prove me wrong."

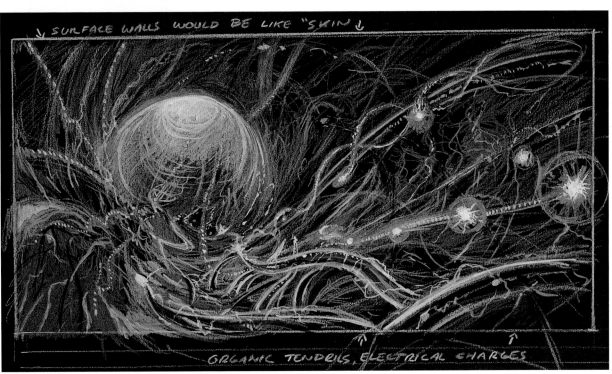

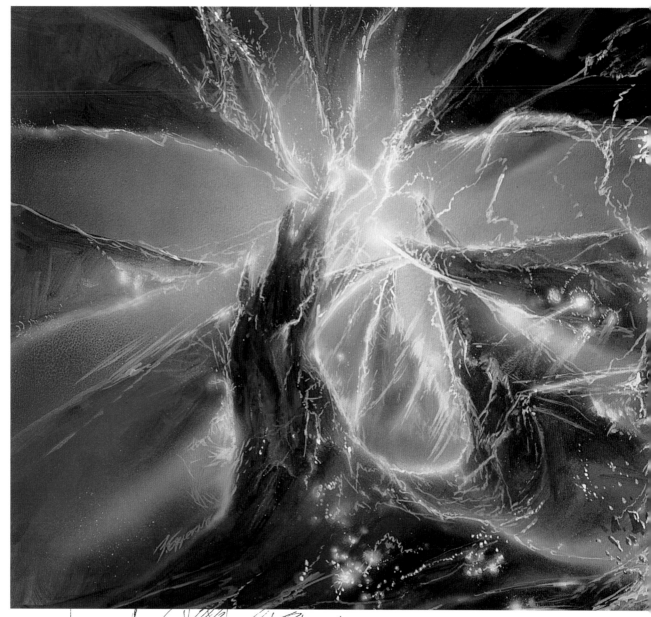

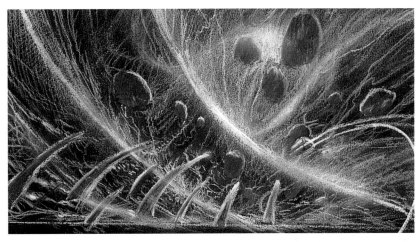

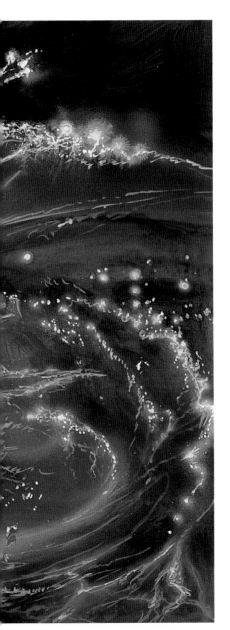

Crystalline Wormhole, 1996
(left)
15 x 20 cm (6 x 8 in)
Pastel and coloured pencil on
black paper
Concept sketch

Untitled, 1996 *(above)*
7 x 15 cm (3 x 6 in)
Pastel and coloured pencil on
black paper
Concept sketch

Untitled, 1996 *(below)*
7 x 20 cm (3 x 8 in)
Pastel and coloured pencil on
black paper
Concept sketch

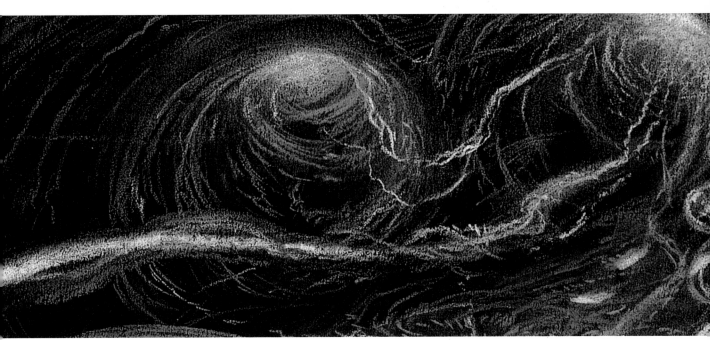

Shortly after working on "Star Trek: The Experience", Bob was asked by the same director, Mario Kamberg, to come up with an idea for a minute-long special effects sequence for the then upcoming film *Sphere*, based on the book by Michael Crichton. The idea was to show the audience what it might be like to fly into a black hole in a spaceship. The black hole was supposed to be simultaneously beautiful and terrifying. The concept involved showing planets and every other kind of debris being sucked into the white-hot accretion disk of the black hole.

They also explored concepts for INSIDE the hole itself. The sketch (facing page below) shows one idea. Bob: "No-one really knows what's inside a black hole, apart from the singularity, which is the actual mass of the black hole and is maybe the size of a pinhead. The gravity of a star collapsing to the size of a pinhead creates such a gravitational well that not even light can escape it, hence a "black" hole. The area of blackness you see in this painting is actually the "event horizon" where light ceases to be seen. As the black hole sucks in matter, it increases the size of the "Schwartzchild Radius" by which the event horizon is measured (I did learn SOME things in college!). Therefore, I speculated, each time this happened, it might leave behind a ghost "shell" from before, much like the rings of a tree that show its age. This seemed a good way of representing something visual to amaze viewers. But it is all idea and speculation since, while it appears we now have a photo of a far-off black hole, we will most likely never see the inside of one, except in films. Sadly, while I was paid for my work, the film was then re-budgeted and this storyboarded sequence didn't make it, as is, to the final shooting script. This was disappointing but everything is, as they say, a learning experience and I feel better for having done it."

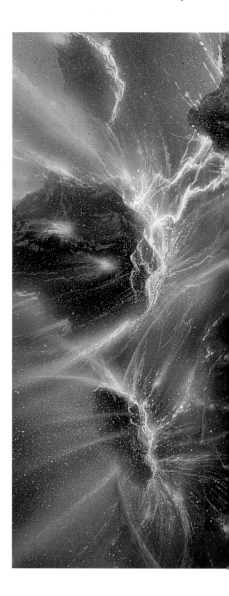

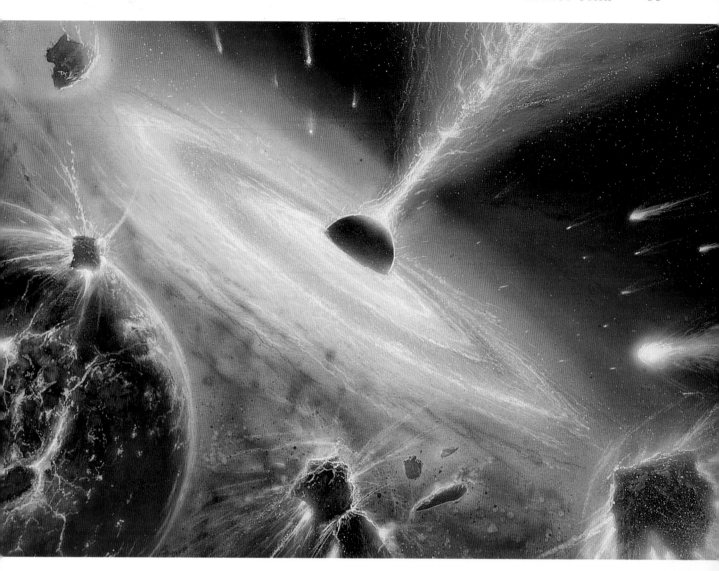

Cosmic Hunger, 1996 *(above)*
26 x 36 cm (10 x 14 in)
Acrylics on board
Special effects concept

When working for Hollywood, ideas
often must be generated at rapid-fire
speed. Ideas are more important than
anything as they lead to the final
image. The final painting had to be
executed in less than a day when it
came to the wire.

Cosmic Hunger sketch, 1996
(facing page)
7 x 15 cm (3 x 6 in)
Marker and coloured pencil on
black paper
Concept sketch

Untitled, 1996 *(above)*
7 x 15 cm (3 x 6 in)
Pastel and coloured pencil on black paper
Concept sketch
A coloured pencil concept of the "inside"
of a black hole, with successive layers of
"past" event horizons.

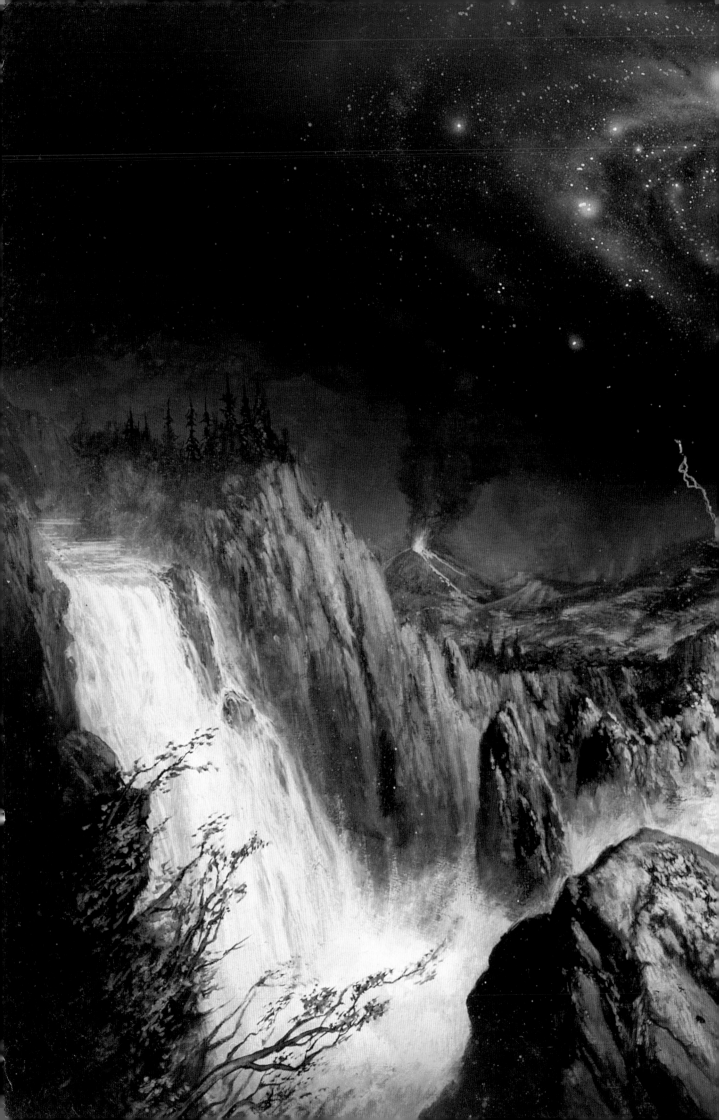

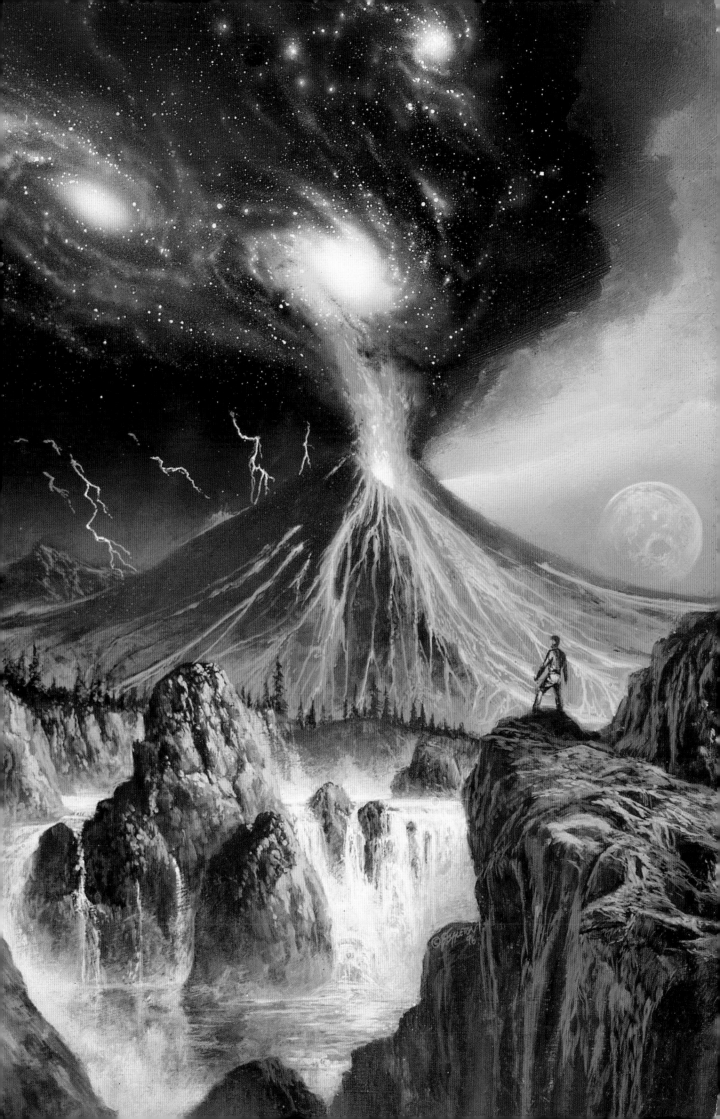

The Sky is Falling, 1996

(previous pages)
40 x 66 cm (16 x 26 in)
Acrylics on board
Cover for *Synthesis and Other Virtual Realities* by Mary Rosenblum, Arkham House Books
This collection of short stories was published by my late friend Jim Turner at Arkham House. Jim just let me loose with the cover and I had fun with the concept of a virtual reality chamber that could reproduce the ancient prehistoric Earth. In this instance, the universe, galaxies and all seem to be falling into an erupting volcano. I could not resist this challenge. The result was a tribute to one of my artistic heroes, Albert Bierstadt.

The Saturn Game, 1996 *(right)*

33 cm (13 in) diameter
Acrylics on board
Cover for the novel by Poul Anderson, Science Fiction Book Club
For this classic story by Poul Anderson I wanted to convey a feeling of Chesley Bonestell, despite the fact that, in truth, the Saturn moon, Iapetus, is probably devoid of any high ice mountains such as these. I call this artistic licence. I find much of the so-called "accurate" astronomical art boring because it's too grounded in facts.

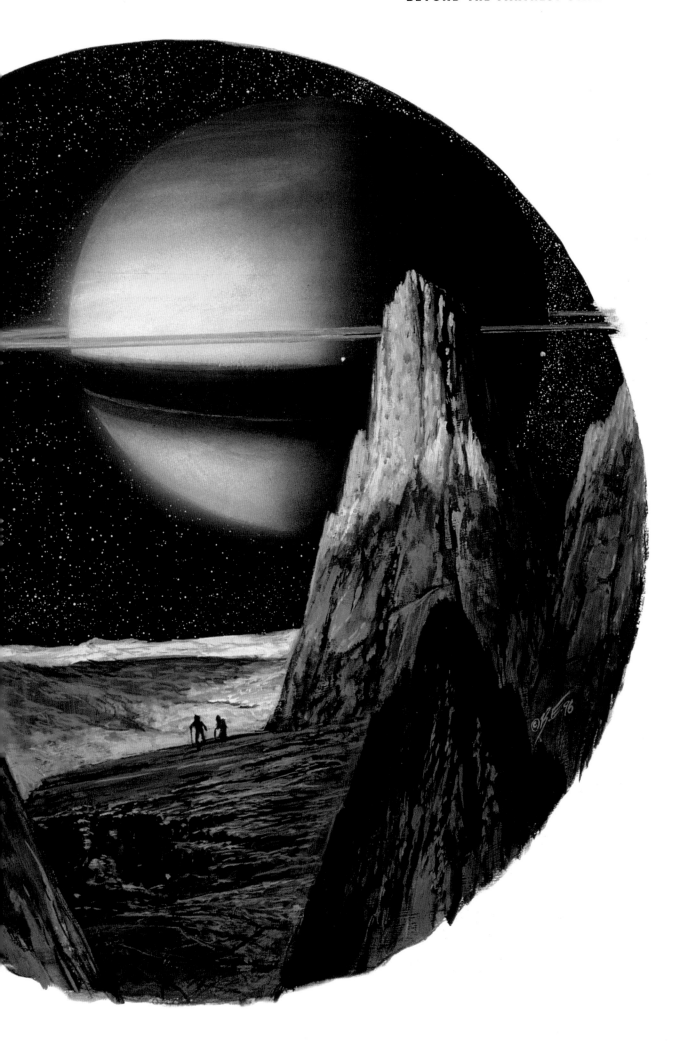

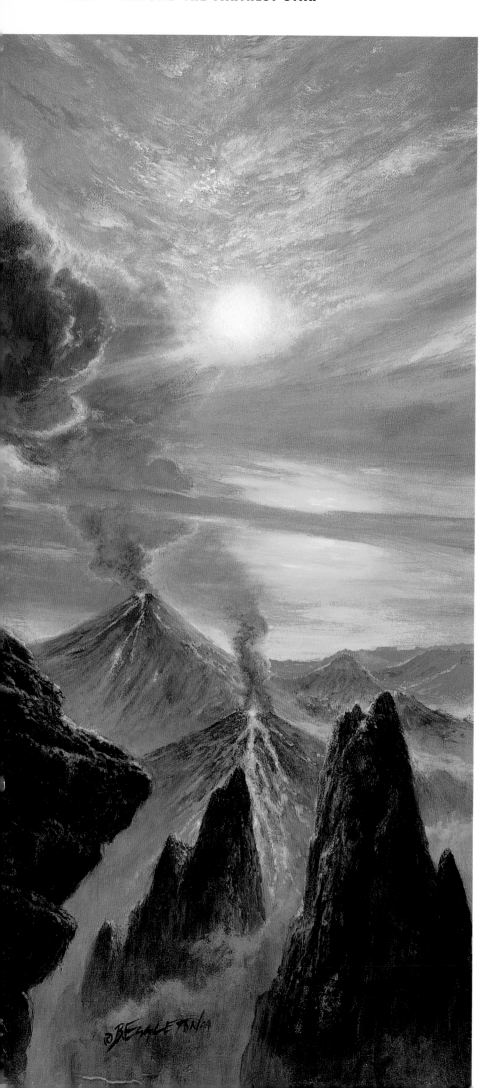

Double Sunset, 1999 *(left)*

60 x 30 cm (24 x 12 in)

Acrylics on canvas

Private work

Most star systems, it's believed, are comprised of binary suns. This would mean our own companionless sun is somewhat of an oddity. On this young planet however, the two suns' shifting gravities are creating major geological problems on the planet surface. I like watching sunsets and cloud patterns, the effects of light...I often wonder what they would look like with two setting suns...

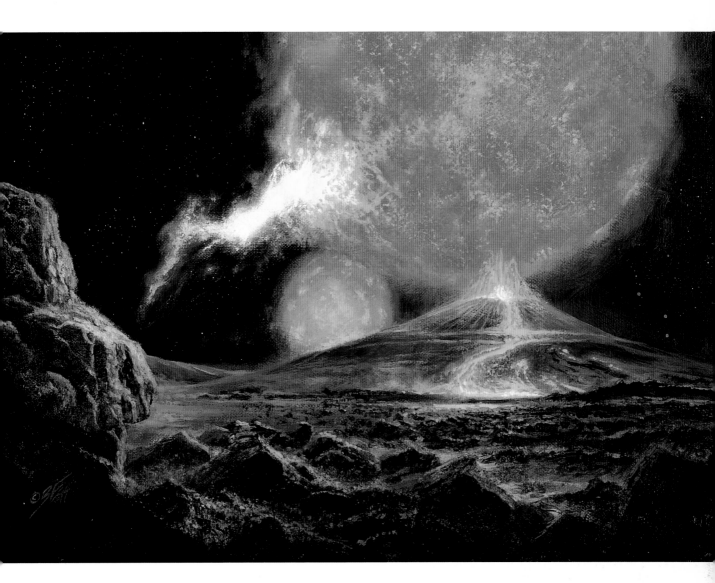

Flare Star, 1999 *(above)*
30 x 60 cm (12 x 24 in)
Acrylics on canvas
Private work
On this fiery planet, we see the effects of a red dwarf flare star. For unknown reasons, this binary star system shoots out flares of white-hot gas. The resulting effects would probably strip any atmosphere from closer planets and create eruptions and earthquakes. The fun part was doing the rocks. I think I did this little painting in about four hours, just for fun.

Bob's private paintings cover the whole range of his work. Some are jokey horror pieces, or they might be dragons, spaceships, straight landscapes or vast panoramas of distant nebulae. The interesting thing is that while they are painted purely for his own pleasure, about half end up being published or bought anyway so it's no great self-indulgence. Also he finds that private painting always recharges his enthusiasm for commissioned work.

With pure spacescapes like these, people tend to feel all or nothing for them. But interestingly every single one so far has been sold to collectors. They sell far better for some reason than paintings with aliens or spaceships in them and have seen Bob through several lean periods when the demand for other aspects of his work has slumped.

What he enjoys is trying to capture the vast barrenness of space and its endless indifference to us. Such paintings are usually much more comfortable, for some reason, when they do not contain any people. To Bob, it often feels as if placing a spaceship or human in the picture somehow bars the viewer from entering. It can also date a picture, whereas a pure spacescape is timeless and "classic". On the other hand, sometimes they can look better with a focus point or figure in them, there are no fixed rules.

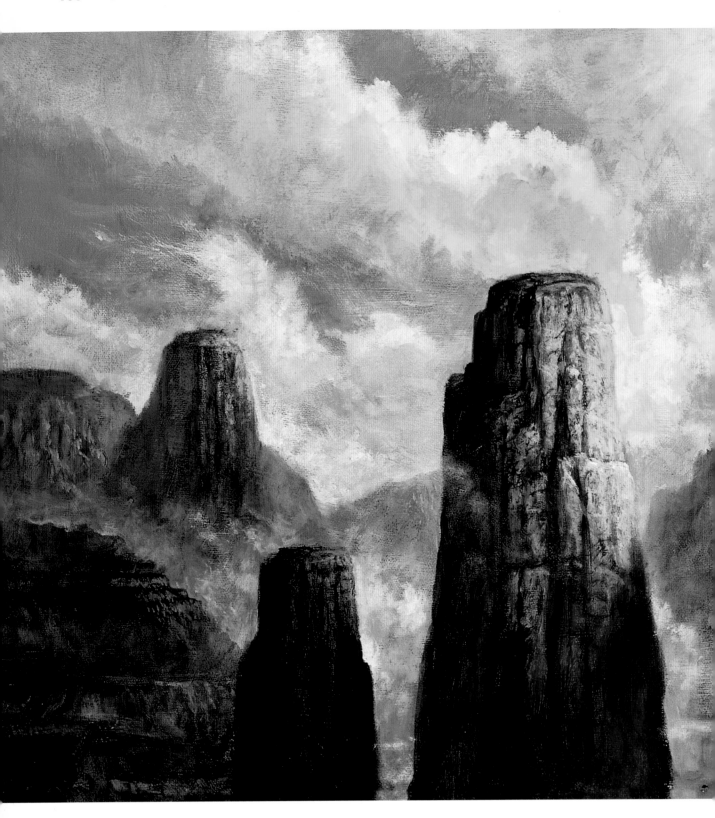

Rainbow Mars, 1998
38 x 76 cm (15 x 30 in)
Acrylics on canvas
Cover for a novel by Larry Niven,
Tor Books
Niven's view was of an old Mars, one
with canals that are filled with water.
I did this shortly after a visit to Sedona,
Arizona, where I was inspired by the

tall buttes and giant towers of age-worn
red rock. A magical place indeed.
Armed with inspiration and photos, and
the request to "paint a romantic Martian
landscape" I set about creating a big
book look. I had terrific fun using
various scraping effects for the rocks.
And, what's more, there's not a bit of
airbrush in the whole thing.

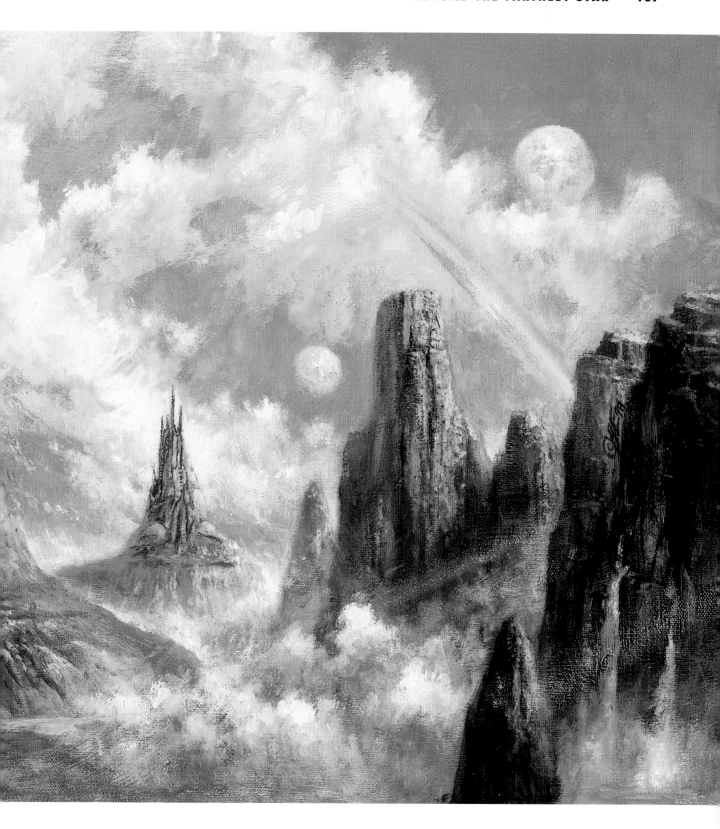

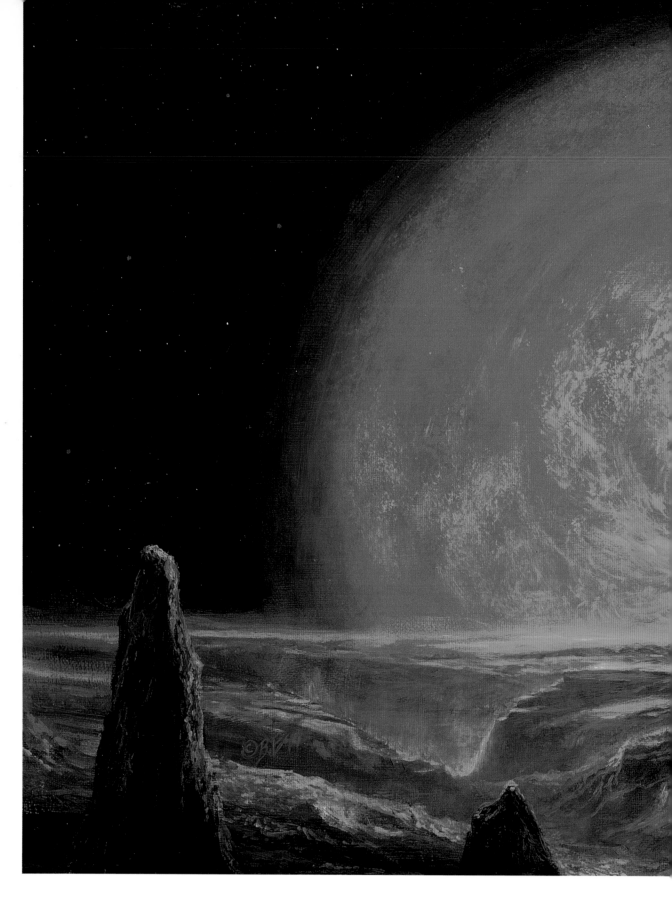

Red Giant Sun, 1998

40 x 50 cm (16 x 20 in)

Acrylics on canvas

Editorial illustration for *Bild Der Wissenschaft* magazine (Germany)

In about 25 million years the sun, our sun known as Sol, will exhaust the hydrogen fuel in its core. The result will be not only a dramatic cooling in temperature, but also a huge increase in size to perhaps 100 times what it is at present, as mass decreases at the core and there is nothing to stop the inside pressure from pushing outwards. After many more years, the sun will lose this outer layer and it will be fluffed into space forming an exquisite ring nebula with a dying, cold, white dwarf star at its centre. The Earth by then will be a blasted cinder. We are viewing the sun from Earth in this picture.

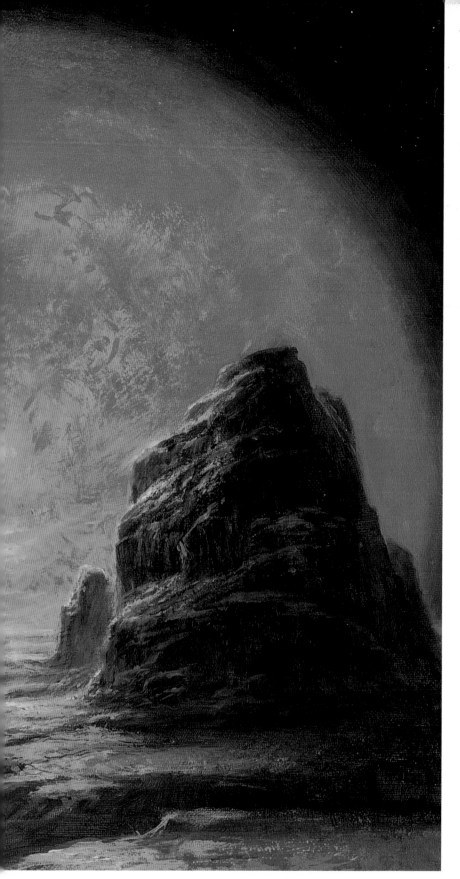

Warped Universe, 1996 *(above)*
36 x 28 cm (14 x 11 in)
Acrylics on board
Magazine cover for *Bild Der
Wissenschaft* (Germany), *Astronomy
Magazine* (US)
The universe is a series of unknowns
on top of unknowns. There are forces
so strong, such as black holes, which
can literally bend light so as to make it
appear that a massive galaxy with
400 billion stars is actually warping
and twisting.

For the future, Bob hopes to be able to continue with all the current strands of his
work and also expand into any other new fields that present themselves. His is a
restless spirit, rarely satisfied for long with any achievement: "I like to consider myself
a multi-medium, multi-subject artist. I don't really want to be pinned down to just one
type of work. In the future, I'm hoping to be able to get more into sculpture for a
while. That would be great, making dragons in full 3D instead of having to guess at
half of them in a picture." The only problem might be fitting them into a book.

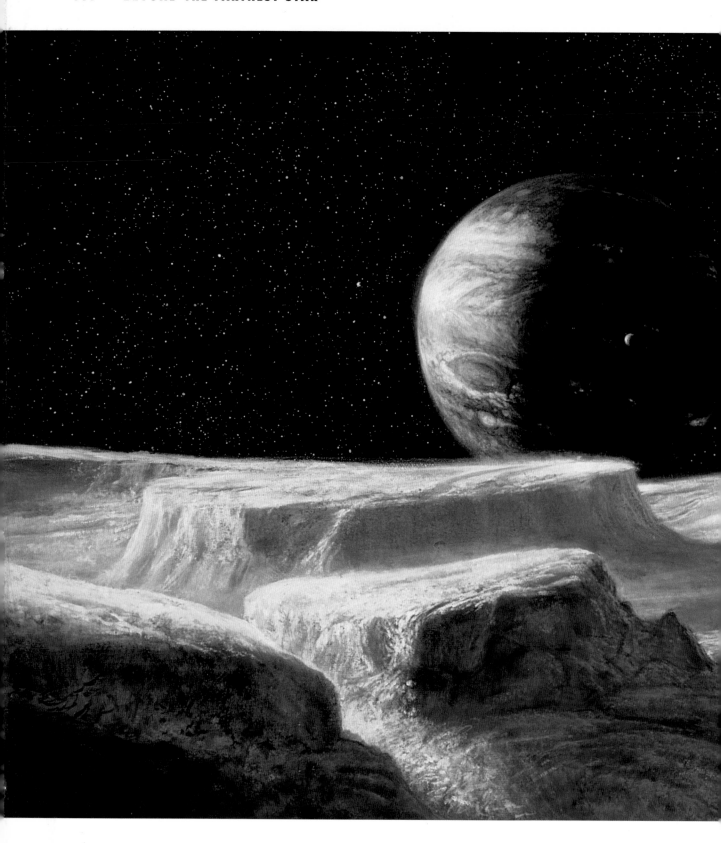

Ocean of Ice, 1999
38 x 76 cm (15 x 30 in)
Acrylics on canvas
Private work
On Jupiter's moon, Europa, there exists
a strange sea of giant chunks of ice,

seemingly frozen over a liquid ocean.
The Galileo probe took some
amazingly close shots of the surface,
and one can only wonder what it
might be like to tread the pristine ice
surface of such a place. It's unlikely

humans could visit this desolate moon
for very long: Jupiter's radiation belts
are so charged by the sun that a
human would probably be dead after
15 minutes, even with the protection of
a spacesuit or spaceship.

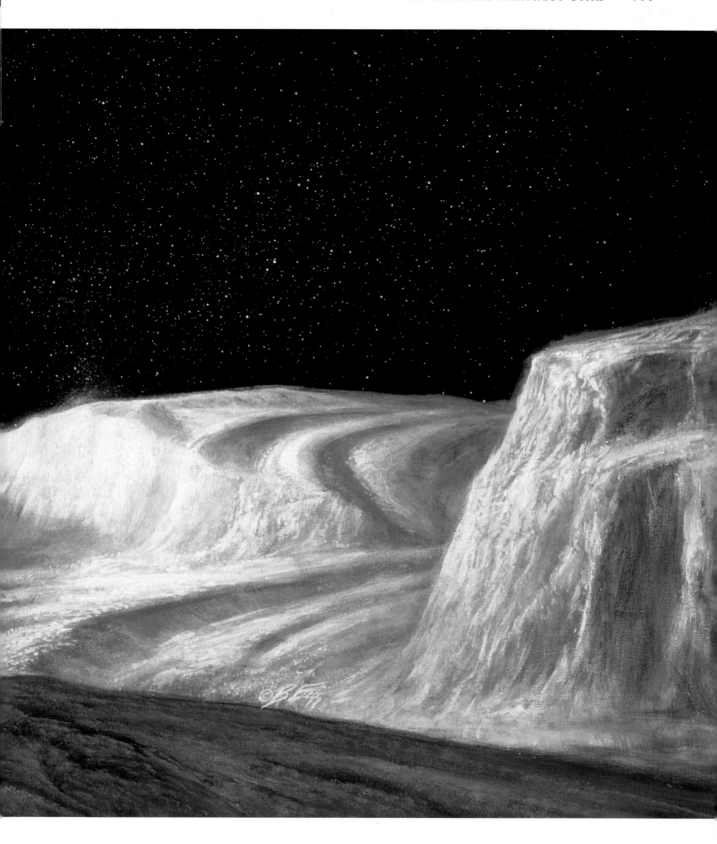

A final word from Bob to any aliens who may happen to find this book: "And there you have it. From the beginning of Earth to the unending infinity of space, these are 'Greetings From Earth'. This represents 20 years in the field of science fiction and fantasy for me, so in effect it's a look into my life as well. I hope it was at least, interesting. Oh, and if you are in the neighbourhood, drop by and visit Planet Earth, but just land where EVERYONE can see you..."

Acknowledgements

Bob Eggleton would like to thank the following people: Nigel Suckling who, for the third time around, did a superlative job of narrating what was only an idea not so long ago. To everyone at Collins & Brown: Cameron Brown, Liz Dean, Muna Reyal, Paul Barnett, Terry Shaughnessy, Sonia Pugh and anyone who has handled even a packet of mail containing materials – thanks all again, for believing in my work. Thanks to Paul Wood for his terrific design. To Marianne for making things (like life) just a bit easier. To my departed Dad – thanks for the "common sense", this one was for you; to Mum for the art classes and hot meals and "proper" tea. To Ishiro Honda, Tomoyuki Tanaka, Eiji Tsuburaya, Akira Ifukube and Harou Nakajima – "Team Godzilla" you made my wonder soar. To Bjorn Ulvaeus, Anni-Frid Lyngstad, Agnetha Faltskog, and Benny Andersson – Thank You For The Music...and to the fans and artists everywhere of science fiction and fantasy – thanks for the last two decades and for the future the way it was...